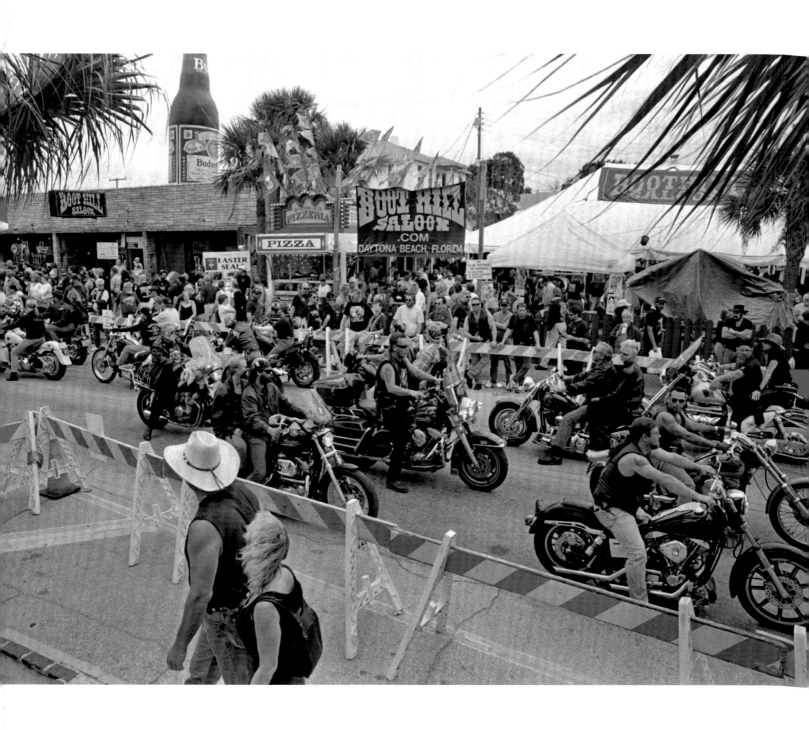

# BIKE WEEK
## AT DAYTONA BEACH

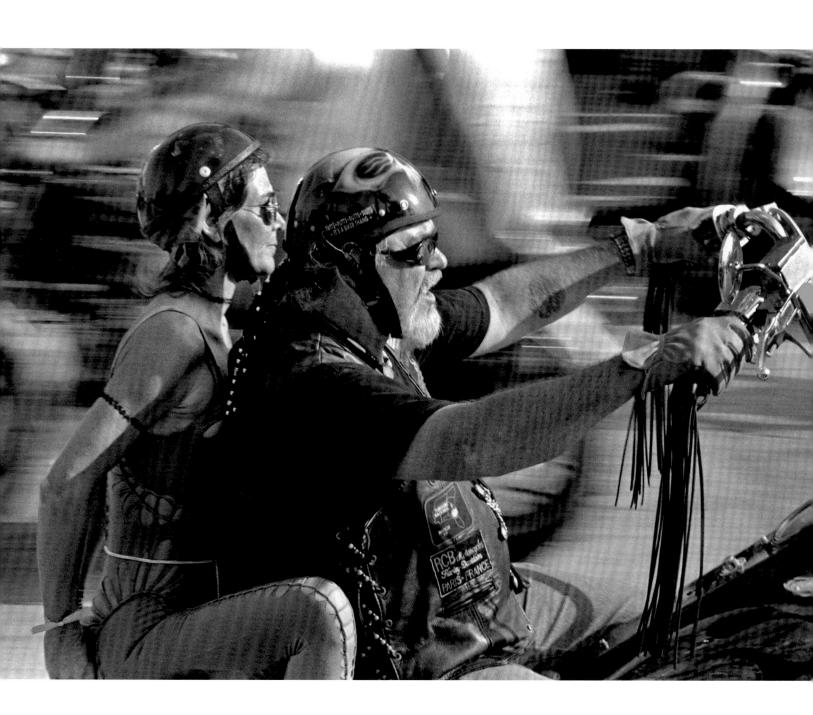

# BIKE WEEK
## AT DAYTONA BEACH

Bad Boys and Fancy Toys

ROBY PAGE

University Press of Mississippi / Jackson

www.upress.state.ms.us

Designed by Todd Lape

The University Press of Mississippi is a member
of the Association of American University Presses.

First edition 2005
∞
Library of Congress Cataloging-in-Publication Data

Page, Roby, 1966–
 Bike Week at Daytona Beach : bad boys and fancy toys /
Roby Page.— 1st ed.
   p. cm.
 Includes bibliographical references and index.
 ISBN 1-57806-764-2 (cloth : alk. paper) — ISBN 1-57806-765-0
(pbk. : alk. paper)
 1. Bike Week (Daytona Beach, Fla.)—Personal narratives.
2. Motorcyclists—United States—Social life and customs.
3. Page, Roby, 1966– I. Title.
 GV1060.149.B55P35 2005
 796.7′5′0975921—dc22                    2004025150

British Library Cataloging-in-Publication Data available

To my mother, Suzy,
who fostered within me
a sociological imagination;

to my father, Gene,
who taught me photography;

and to my brother, Gene,
who introduced me to bikes

## On the Road to Bike Week

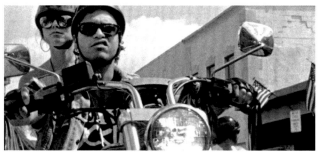

## Bikers and Boutiques

# Contents

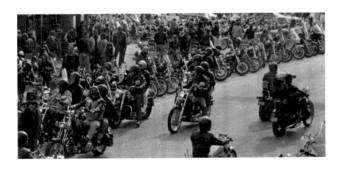

## Bike Week at Daytona Beach

## The Pursuit of Authenticity

# Introduction

In the summer of 1998, about a hundred motorcycles made their way inside New York City's Guggenheim Museum. They came not to wreak havoc but as part of the museum's exhibit, The Art of the Motorcycle. Nevertheless, there was a disturbance. Describing the ensuing controversy over the "rumble on the ramps," *Newsweek* magazine asked, "Does this mean art is dead?"[1] Disputing the value of the motorcycle as an art form, one critic dismissed the display as "pathological." Others defended the artistry of motorcycle designs and praised the populist appeal of the show. The Art of the Motorcycle proved to be the most popular exhibition in the Guggenheim's history.

While some resistance to such an exhibit might have been expected, the idea of motorcycles in the Guggenheim hardly should have seemed surprising by 1998. The museum's exhibit actually had been in the works since about 1990—when the motorcycle resurgence, at least for the revived Harley-Davidson Motor Company, was just gaining momentum. In an earlier time, more observers might have agreed with the critics, that motorcycles should not tread on such hallowed ground or that they are not worthy of such celebration. Such reservations would have been due in part to outlaw and other deviant associations often connected with motorcycles in years past.

By the 1990s, however, these associations increasingly were offset by the changing image of bikers. The defenders of high culture still might reject motorcycles as noisy, dirty, and perhaps trendy playthings for the commoners. But on balance, the images of motorcycling and bikers had shifted far enough toward the socially acceptable and even desirable that the idea of motorcycles in the Guggenheim became feasible.

Exhibits on motorcycles presuppose their objects as cultural phenomena. Certainly, a motorcycle is a cultural phenomenon, even if it is considered simply as a basic mode of transportation. But the added meanings that often are attached to the machines, and which will be explored below, infuse motorcycles with additional cultural significance.

While the motorcycle has always been a functional means of transportation, it also developed as a symbol for freedom and individuality, among other things, and as such has been at times viewed with apprehension and at other times celebrated with enthusiasm. Motorcycles traditionally have been associated more with the young, the working class, and the deviant. These associations have recently been replaced, or at least overshadowed, by images of the middle-aged, the middle class, and respectable conformity. Thus motorcycles—and Harley-Davidsons in particular—have traveled a road from disrepute to Main Street.

# On the Road to
# BIKE WEEK

**It is midmorning. My bike is loaded, and I am charged with the anticipation of a long road trip. I open the fuel line, turn the key, flip the power switch, pull out the choke, and press the crank switch.**

The twin-cylinder, 883-cc engine resists the cold as usual but soon chugs to life. I let it warm up for a few minutes while fastening my helmet strap, putting on my gloves, and settling into the saddle. I drop the shifter into first gear, and the journey begins.

In five minutes I am already out of my neighborhood and on the highway heading south. I self-consciously imagine that other motorists, cocooned away in their cars and trucks, must consider me a little crazy. Motorcycles being a relatively vulnerable mode of transportation, I hope that others will recognize my particularly pitiable situation and take whatever extra steps they can to make way for me. Of course, years of riding have taught me to assume automatically that other vehicles are targeting me like the hammer targets the nail. So I immediately dismiss the thought as a pipe dream.

It is cold. Capital-C, C-o-l-d, Cold. The skies are overcast, and the temperature is 24 degrees Fahrenheit. I wind along the lightly traveled highway at a casual 50 miles per hour, wanting to get south as soon as possible but wanting even more to not increase the windchill. Beyond the mere chill from the low temperature, my muscles quickly grow tense, especially in the legs. My hands and fingers grow numb as they cling through thick gloves to the handlebars, leading the way into the cold wind. My 1988 machine didn't come with the luxury of heated grips. My nose starts running, requiring a frequent one-handed wipe. I occasionally rest my left hand on top of the engine to thaw my fingers as much as possible. My right hand on the throttle, I tighten the throttle's tension knob so that hand can get some thawing on the engine, too. I resist the temptation to squeeze the handlebars too tightly in order not to hamper blood flow in my fingers, which I keep moving in a hopeless attempt to stave off numbness. Similarly, I frequently move my feet from the front pegs to the middle pegs, and back again.

Riding in the cold is not something I do just for kicks. Add rain, and what you have is a very unappealing experience. Snow and ice? The latter, at least, simply does not work with two wheels. No doubt there are tough guys out there who would say it doesn't matter to them. But surely tense muscles, numb limbs, stinging raindrops, wet clothes, and slick roads are all happily avoided.

Inclement weather may affect different riders in different ways, but it's probably safe to say that most would prefer 70 degrees to 40 and dryness to wet roads and a soggy seat. It is no accident that the season-opening and world's largest bike rally is in the Sunshine State—at Daytona Beach, Florida. There are major rallies in northern states, such as Sturgis, South Dakota, and Laconia, New Hampshire, but those come between June and August, not at the first of March. Bike Week in Daytona Beach is where I am headed, coming out of the Blue Ridge Mountains of Virginia.

I have been watching the weather closely for a few days, hoping that cold front out of the northwest will weaken and not make my life difficult. Despite it being the last week of February, I had figured it wouldn't be too bad to ride out in a morning temperature of about 40 degrees. Well, at least it's dry. An hour or two down

the road and some midday warming will surely be in the offing. Furthermore, I am headed south, so it will only get warmer. Florida, here I come.

I am traveling a four-lane U.S. highway rather than the interstate. This will help in at least two ways: the interstate traverses the mountains for about a hundred miles before descending into the piedmont at the North Carolina border. My chosen route slips me into the Virginia piedmont almost immediately, and this more easterly route might help me avoid the worst of the front. Second, the U.S. highway will allow me more frequent options for stopping and a more leisurely pace so that high-speed winds will not further chill the already subfreezing temperature. If these are not reasons enough, any rider knows that it's much more biker-correct to take in the character of secondary roads as opposed to the soulless interstates.

I have never invested in electric clothing, so I am wrapped up the old-fashioned way with multiple layers from head to toe. Starting from the bottom: my feet are covered with a regular pair of socks, under a pair of heavy wool socks, under a pair of sturdy, waterproof, brown hiking boots that cover the ankles. My lower body is covered with a layer of thermal underwear and a pair of blue jeans. My upper body is covered with a thermal undershirt, a T-shirt, a long-sleeved cotton pullover, a sweatshirt, a fleece jacket, and a medium-weight brown leather jacket. Covering my hands are glove liners under my lined, black leather gloves. I've never owned a full-face helmet; instead, I'm wearing a black three-quarters helmet with a snap-on face shield over a lined rabbit-ear cap that fastens with Velcro under the chin. Around my neck and over the lower half of my face is a cashmere and wool scarf. Nimble I

am not. I also am carrying a rain jacket and matching rain pants, although these were not made for motorcycling and therefore are vulnerable to seepage.

And now my load: on the backseat sits a duffel bag containing clothes and other personal items. On top of that sits my camera bag, including two 35 mm camera bodies with motor-drive attachments, a 24 mm lens, a 135 mm lens, and a flash. Behind the foot-high backrest and over the bike's license plate I strapped my two-person dome tent, a sleeping bag, a sleeping-bag support pad, and a ground tarp. It all makes for a fairly large and slightly top-heavy load, but it could be scaled down no further. Saddlebags would have helped, but I've never owned any.

Packing for a bike ride is a satisfying exercise, trying to include everything that will be needed while omitting as much as possible. The final determination of what makes the trip is what can be properly strapped on the bike. In packing for various bike trips through the years, it seems I have usually been forced to make a few last-minute exclusions. The pile on the backseat makes a nice cushion to lean back on so I don't have to fight the wind as much. With no windshield or fairing on my bike, I lack protection from the wind's force and its chill, as well as bugs and other flying objects. This was an aesthetic consideration that I settled years ago, but I readily admit that a more practical setup would be welcome this cold morning.

I've been interested in biking since I was eighteen, when my brother, Gene, returned home to Florida from service in the U.S. Air Force and chose as his transportation a Harley-Davidson Sportster. Gene had a minibike during our younger years in the early 1970s, and while stationed in Germany he had taken to the hard-edged

ways of the biking crowd. I did not have much interest in minibikes or motorcycles, and this remained the case for a while, even after Gene bought his Sportster and lived nearby as we attended college together.

The following year, I went to Daytona Beach for Spring Break with some friends while at the same time Gene went to Daytona Beach for Bike Week with some of his new biking friends. We got together a couple of times during the week, so I had more than just a passing glimpse of the biking scene. It was my first Spring Break and my first Bike Week, and I found the latter to be far more interesting.

Bike Week at that time was saddled with a more disreputable image than accompanies the festive event of today. Where now it is a welcoming festival (perhaps retaining a few rough edges), then it was still regarded as an unseemly and potentially dangerous gathering looked upon with consternation by local officials and residents. The central Main Street was an uninviting and supposedly dangerous place. But I was struck by the incongruity between the obviously friendly and seemingly harmless bikers whom I confronted on the street and the unfriendly, villainous image that I had learned to associate with bikers. In time, I would also identify with the outsider perspective often connected with bikers, particularly in its truth-seeking form as famously portrayed in the 1969 film *Easy Rider*.

While Bike Week and Spring Break have continued to run together as they did in 1985, I never attended another Spring Break and instead made Bike Week a rarely missed annual pilgrimage, continuing in the following year on a Sportster of my own. First as a photojournalism student and later while studying sociology, I always approached Bike Week as a photography project. Occasionally, my photographic intentions would be explicitly designed for particular class assignments. In other years, I continued my ongoing photo project just as eagerly, although with only vague objectives.

Over time, my friends and I began to notice how Bike Week was changing. In the late 1980s, the city of Daytona Beach seemed to start taking a more favorable view of the event, most obviously evidenced by banners strung across Main Street welcoming bikers. Then in the 1990s, we watched Bike Week become more popular and respectable with each passing year, as more and more people took to riding Harley-Davidson motorcycles. The renegade biking spirit, at least as manifested in Daytona Beach, increasingly yielded to a spirit of festive community. It was with these observations in mind that I set out this year for Daytona Beach, seeking to get a better understanding of exactly how and why Bike Week had changed.

The miles roll by as I constantly check my trip meter. Thirty, forty, fifty. . . . Nearing the North Carolina border, raindrops begin to fall. This is not a happy development. I pull under the cover of a large gas station and convenience store. After just a few wonderful minutes of warmth inside, I feel the need to move on, wanting to get south ahead of the cold front and sure that more southern latitudes plus the approaching midday add up to warmer riding. I put on my raingear and get back on the road, hoping the rain will remain light and quickly end.

I soon feel a sense of progress as I cross into North Carolina. Only three more states to go, I encourage myself, deceptively. Moments later the raindrops do

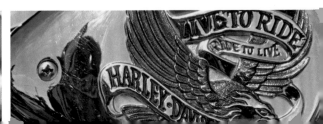

stop, only to be replaced by snowflakes. Ever optimistic, I figure at least now it will be easier to keep dry. Just get south . . . get south of the bad weather, I keep thinking. The situation was workable well north of here where I started, and I'm traveling about 55 miles per hour. Surely I can outrun the weather.

The road soon looks a little brighter, but it isn't the effect of clearing skies. An icy whiteness grows in the blur below my feet, in the edges of the lane and in the middle. I steer the front wheel to the lane's tire tracks, knowing that on two wheels ice is an unworkable situation. Pessimism grows inside me, a creeping feeling that my calculations are being foiled and that I am being penned in. The farther I ride the worse it gets, and I begin negotiating a surrender. I start looking for a roadside refuge, but the quiet highway offers only another long hill or another broad curve. After about ten lonely miles of sudden desolation and worsening conditions, an old truck stop appears ahead on the left. Preparing to change lanes across the ice, I slow to below 30 miles per hour and gingerly begin drifting toward the left lane for the approaching median crossing. In the next instant, I was on the ground sliding behind my bike, which was sliding on its left side.

Somewhat dazed but uninjured, I quickly began to lift the bike to get off of the road. Another motorist quickly appeared out of the gray and helped me get my bike up and into the median as a tractor-trailer eased to a stop behind us. I assured my helper that I was all right and thanked him for his assistance, then walked the bike over to the truck stop and under an awning to take stock of my situation. Aside from a few scrapes, the bike suffered a broken left tail lamp and a broken gearshift pedal, the latter rendering the bike inoperable. The ice had effectively done that already.

My plan was to arrive in Daytona Beach Friday afternoon. I was leaving Virginia a couple days early so I could attend the Thursday funeral of my great-aunt in Tampa. So I needed to be in St. Petersburg Wednesday night. And here I was, a little before lunch, Tuesday, shivering in northern North Carolina and watching a green field across the highway slowly turn white. It appeared that I would just have to hole up in a local motel for a day or two while I had the gear shifter replaced and waited for the snow to melt, or at least for the roads to be plowed after the snow stopped. Unfortunately, I would have to miss the funeral and instead head straight for Daytona when I could.

I draped my rain jacket over my pack on the back of the bike and went inside the adjoining diner, taking a seat at the counter to order a cup of hot chocolate. The dim room, appearing even gloomier with the dreary window light and with its worn furnishings, looked like it must have looked every gray morning for the past fifty years or more. Probably due to the weather, there were quite a few patrons, sitting at tables or on stools, coming and going. My hot chocolate surely was good, both to drink and on my cold hands.

After about a half hour of considering my circumstances, I used one of two pay phones out front to call the nearest Harley-Davidson dealer, located only about twenty miles farther down the road. They said they'd send a truck to get me. That they did, and with surprising speed. The driver and I pushed the bike up into the truck's bed, and then I was southbound once again, this time in the warm confines of the truck's cabin. Look-

ing at the winter wonderland outside the windows, I had a deeply felt awareness that this was not a bad way to travel. The driver was a friendly fellow who seemed surprised to find a rider out in this weather. Never mind that my bike now was sitting, broken, in the back of his truck.

There is a certain camaraderie among fellow motorcyclists, especially travelers out on the road. This most simply takes the form of riders waving to each other in passing, as boaters often do. It can also be found in shops, as for me this day. Unlike drivers visiting a car dealership, when riders pull into a bike shop while on the road they'll likely receive a little extra attention. There is a greater sense of shared experience among motorcyclists. Those in the shop probably ride themselves, they probably would like to be going to Daytona themselves, and some of them may well be going or at least have gone sometime in the past. Of course, there is a lot of shared experience among those who drive cars. But among motorcyclists there is the crucial sense that the experience that is shared is also experience that is relatively uncommon. Being a motoring minority, and one that traditionally has been both frowned upon and envied, makes members of the motorcycling group take a special interest in each other.

Upon my arrival in Greensboro, the guys in the shop were nice enough to get right on my bike, quickly replacing the broken parts and making my bike well again. They were interested to hear about my trip and to talk about Daytona, conveying respect that I would be making the trip on this dismal day. I was a fellow two-wheeled traveler, perhaps even an authentic biker, one who was headed for the promised land of biking, Bike Week in Daytona Beach, come rain, sleet, or snow. Well, anyway, thanks men, for rescuing this downed rider from icy desolation.

Any motorcycle rider on two wheels is a motorcyclist. One who sees the motorcycle as more than simply a mode of transportation might be labeled an enthusiast. Among the various motorcycle brands, a relatively large proportion of Harley-Davidson riders tend to be enthusiasts. "Bikers," or those resembling the black-leather stereotype, typically but not exclusively ride Harley-Davidsons.

Appearances being an imperfect indicator of what lies underneath, bikers actually are a rather heterogeneous group. There are outlaw bikers—the proverbial 1 percent of all motorcyclists who are involved with an outlaw club. The variety of remaining bikers—call them lawful (nonoutlaw) bikers—make up the vast majority of the motorcyclists seen at rallies such as Daytona Beach and Sturgis. Prior to the 1990s, most of these bikers were what are sometimes referred to today as real bikers. This is to distinguish them from the new bikers, the derisively labeled RUBs (Rich Urban Bikers) or yuppie bikers, who began appearing in the 1980s and increasingly through the 1990s.

One study of the biker subculture further elaborated on the variety of coexisting biker subgroups, all claiming the biker designation and donning the biker uniform of denim and leather. Among these were born-again Christian clubs, a Vietnam veterans club, a club for recovering addicts and alcoholics, and one for lesbian motorcycle enthusiasts. Perhaps the largest, and most diverse, club of all was the Harley-Davidson-sponsored

Harley Owners Group (HOG), an international organization subdivided into numerous local chapters. One HOG chapter was made up mostly of retirees on touring bikes. Another was comprised of mostly new bikers "richly costumed in leather and riding highly customized Harleys down the back roads of midlife crises," said authors John W. Schouten and James H. McAlexander. Yet another consisted of mostly working-class families, many of whom "treated HOG events as mainstay family entertainment and for whom owning one or more Harleys constituted a major financial sacrifice."[1] While there is considerable variation between groups, membership tends to be homogenous within groups.

With each passing year, the distinction between real bikers and new bikers has decreased. This occurs in two ways. Individually, many new bikers grow more experienced in motorcycling and transform themselves into real bikers. Meanwhile, new bikers collectively alter the older ways of biking by bringing with them new ways that become accepted into the biking subculture. Of course, such patterns of behavior and change are always taking place in any environment and therefore are not unique or new to biking. However, certain periods of change, such as that which recently has occurred in biking, are particularly striking. The distinction between real bikers and new bikers is central to understanding the change that has occurred at Daytona Beach's Bike Week and elsewhere in biker culture in recent years.

As the shop finished repairing my bike, I once again had to consider the changes in my circumstances. Only a couple hours had passed since I laid down the bike. Amazingly, there was no rain, snow, or ice on the roads outside, but the guys in the shop told me that snow was expected to arrive at any moment. The snow and the ice had grounded me, you might say, and the truck ride had lifted me just far enough down the road to give me the traction I needed.

So I fire up the bike and speed south out of Greensboro on the U.S. 220 freeway, imagining snow nipping at my back wheel and humming the Allman Brothers' "Southbound" as I go. Now less concerned about the windchill than with making time, I keep my speed up around 75 miles per hour for the next hour until the freeway fades into two-lane country roads in southern North Carolina. Still, I keep on the throttle, wanting to punch as far south as possible in the limited hours before nightfall. As cold as it is, I know I won't be riding after dark. And I want to ensure that I get far enough southward today so that the pursuing snow and ice won't be lying in wait for me come morning, leaving me stranded once again. Finally, I figure if I cover enough miles today, I can get back on schedule and still reach Tampa–St. Pete tomorrow night.

Crossing the border into South Carolina on two-lane U.S. 1 (two more states to go), I set my sights on Florence for the night. Rush-hour traffic and suburban congestion around Darlington slow me as I near Florence on U.S. 52. Actually, the slower speed is a nice change because it reduces the windchill, the stop-and-go gives me a welcome opportunity to exercise my stiff limbs, and the traffic exhaust offers relative warmth while sitting at lights. At times like these, pollution intake is less a concern. I pull into a motel where 52 passes under Interstate 95, tomorrow's soulless and wonderfully efficient route to Florida, and sign in at

the front desk. My numb hand can only scrawl some faint semblance of my name.

I carried with me two locks on this trip, down from the usual four with which I secure the bike at home. I used a heavy five-foot chain, which I carry wrapped around the backrest under my bags, to connect the bike's frame to something stationary—this night a stairway railing on the sidewalk just outside my door. Even the heaviest chains can be cut with relative ease, so I also carried a shorter, heavy-duty cable lock.

It is often said that if a thief wants your bike, he's going to get it. That may be true. Nevertheless, surely it is useful to discourage theft as much as possible by making the bike difficult to steal and perhaps making the next bike more attractive. I speak from experience on this issue. My previous bike—a black Sportster just like my current one but two years older—was stolen from outside my college apartment. I consider my subsequently adopted antitheft methods successful—so far—given that my current bike and I had been together for eleven years as of this trip.

I unloaded and secured the bike and walked next door for dinner. After a long day of riding in the cold, it is very easy to feel extraordinary appreciation for such ordinary pleasures as the warmth of a dining-room fireplace and a good, hot meal. Add a hot shower and a warm bed to the menu. Before falling soundly to sleep, I took in the weather forecast from various sources on the television. Central South Carolina was bracing for unusually cold weather and even the possibility of snow, although it looked like the snow probably would be limited to the western half of the state.

My first thoughts upon waking Wednesday morning were of what it looked like behind the curtains. Peek-ing out the window, the grass was dusted with a light snowfall, and it appeared a sunny day was shaping up. While relieved to see that the streets looked passable, I couldn't help but be impressed by this weather system's determined pursuit of one sun-seeking cyclist. I still had to be on guard for ice on the road, so I took my time getting ready, giving the sun time to do its thing. But I didn't want to dally too long with a five hundred–mile day ahead of me if I was to reach Tampa Bay by day's end.

I roll up onto I-95 southbound and reinstitute my logic that was so naive yesterday but looks like a sure winner today: keep moving south and the lower latitudes and higher sun will provide increasing warmth. Still, after yesterday's mishap, the light snow on the side of the road keeps me mindful of the ice that still might be lurking on the highway, especially on the occasional bridge. About an hour down the road, I cruise over broad Lake Marion under a perfectly clear sky. By now I know I have escaped the wintry conditions, and the road to Florida is wide open before me.

In the next hour, I see another motorcyclist for the first time since I left home. This prompts me to imagine a few days from now when, with the arrival of warmer weather and the first weekend of Bike Week, this stretch of highway will see a continuous stream of motorcycles bound for Daytona. With the sun high in the sky, I cross the Savannah River into Georgia and the temperature must be nearing 50, which by now feels downright tropical. Just one more state to go—although now I allow myself to think about the long ride remaining after I cross the Florida line. I pull off at Savannah's roadside Harley dealership for a rest before motoring on down the Georgia coast.

By the time I cross the St. Marys River and feel the welcome of my home state, it is late afternoon, and the late-winter sun is dropping. I know there is little more than an hour of daylight remaining but still about four hours of riding left. It doesn't matter today. The temperature must be about 60 as I bypass Jacksonville to the west, and the temperature drops little, if any, after dark as I continue south and across the state toward the Gulf Coast. If the comfortable weather is making bike riding a pleasure now, it gets even better as I leave the interstate for a couple hours and enjoy the more leisurely pace of U.S. 301 as darkness falls. Near Ocala, I settle indoors for a tasty barbecue dinner, keeping an eye on the bike and its load through the front window.

Rested and nourished, I have two hours remaining to St. Petersburg. Considering where I started, it seems like only a quick run down Interstate 75. That it is, as I continue basking in the warm wind while reclining comfortably back in the saddle against my bags. Contentedly mesmerized by the rumble of my engine, I glide down the smooth, gently rolling and winding interstate, through the darkness lying behind the warm glow of my amber running lights. The dark blend of trees and sky soon gives way to the brightening light of Tampa. Now invigorated by the energy of the city and the sense of nearing my destination, I speed past downtown, across Tampa Bay, and toward the day's finish line in St. Petersburg, arriving around nine o'clock. My brother and his family are already there at my mother's house.

*Gulls 1985*   **9**

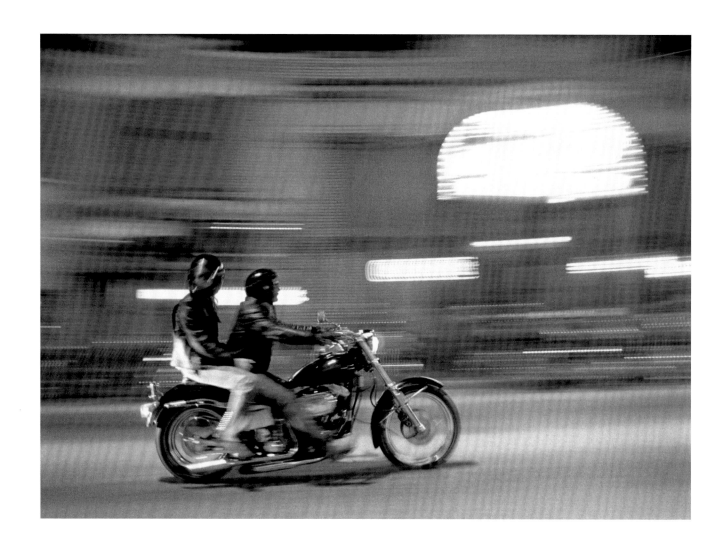

*Main Street 1985*
Right: *Doing the Hokey-Pokey 1988*

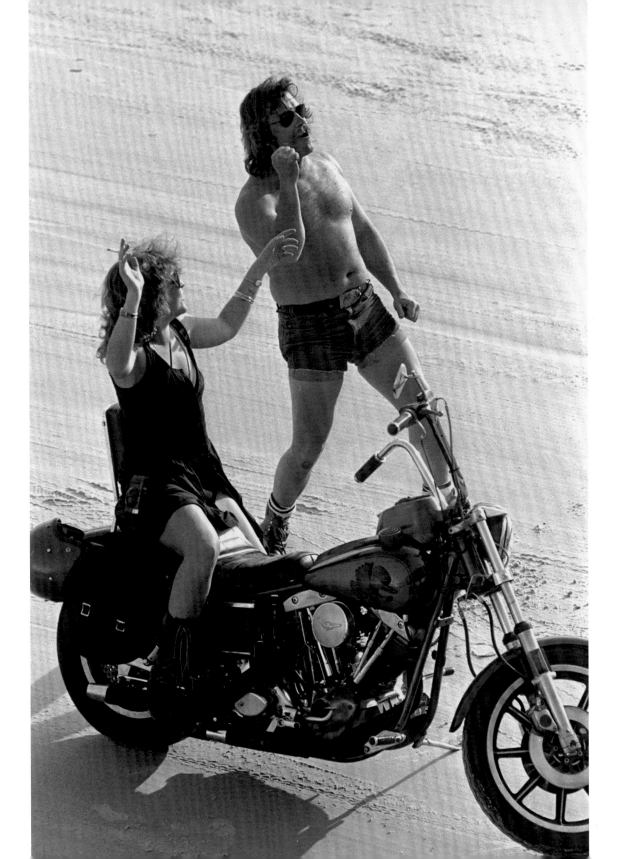

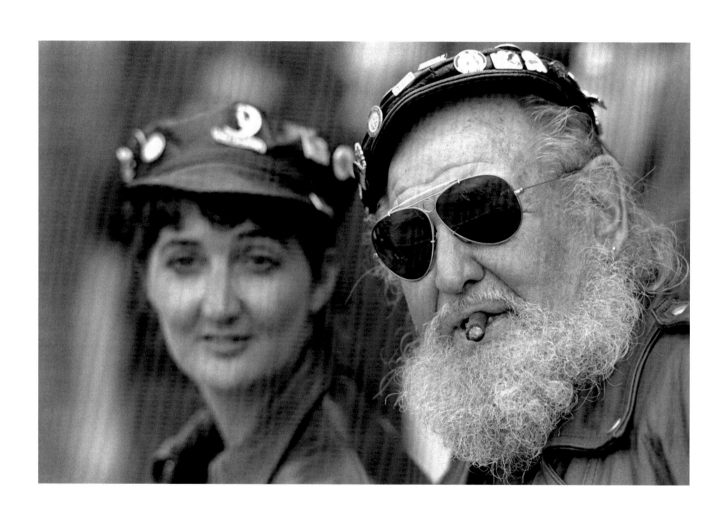

*On Main Street 1988*

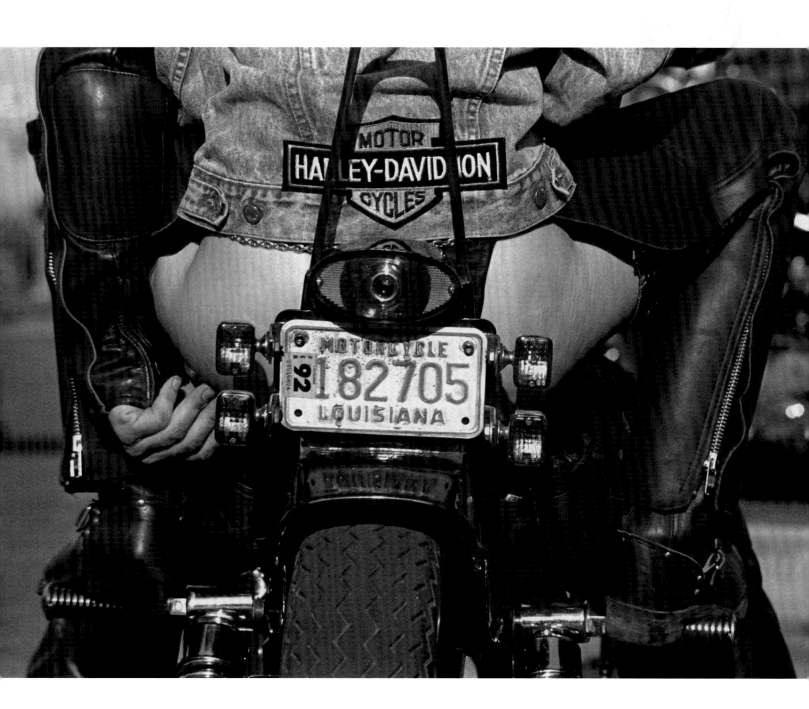

*Louisiana 1989*  |  **13**

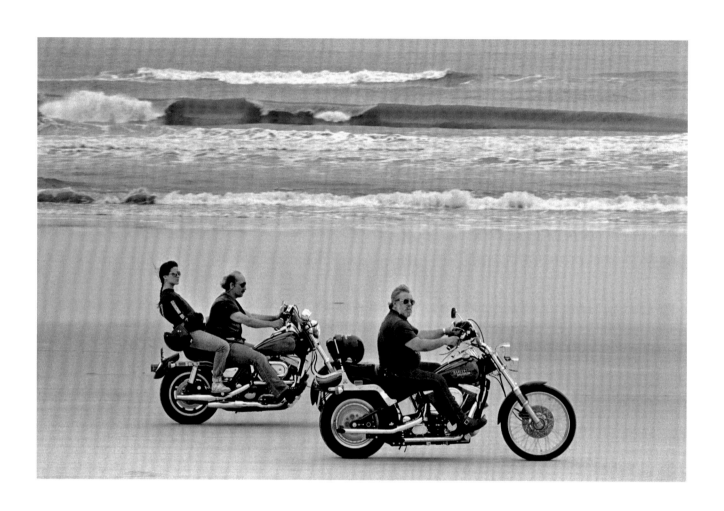

*Riding the Beach 1988*

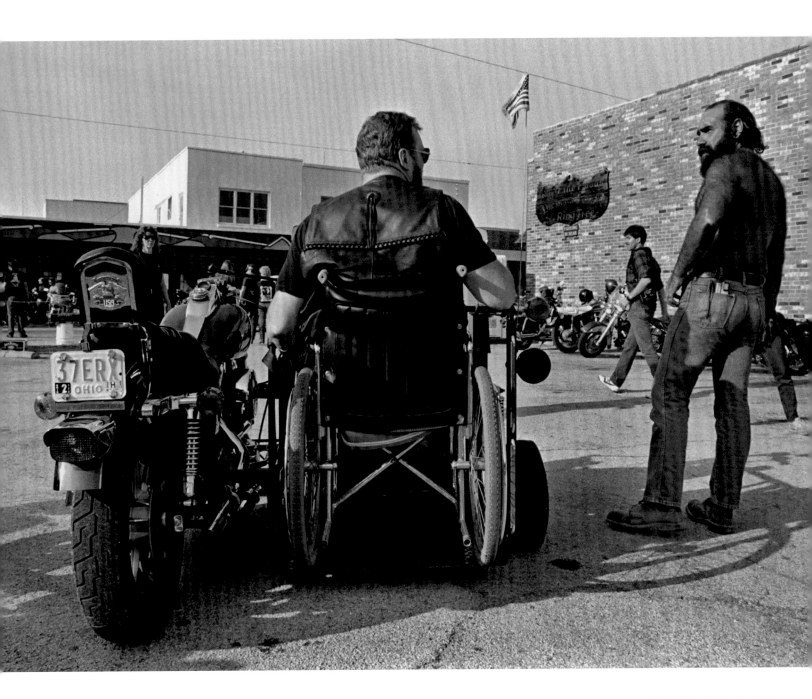

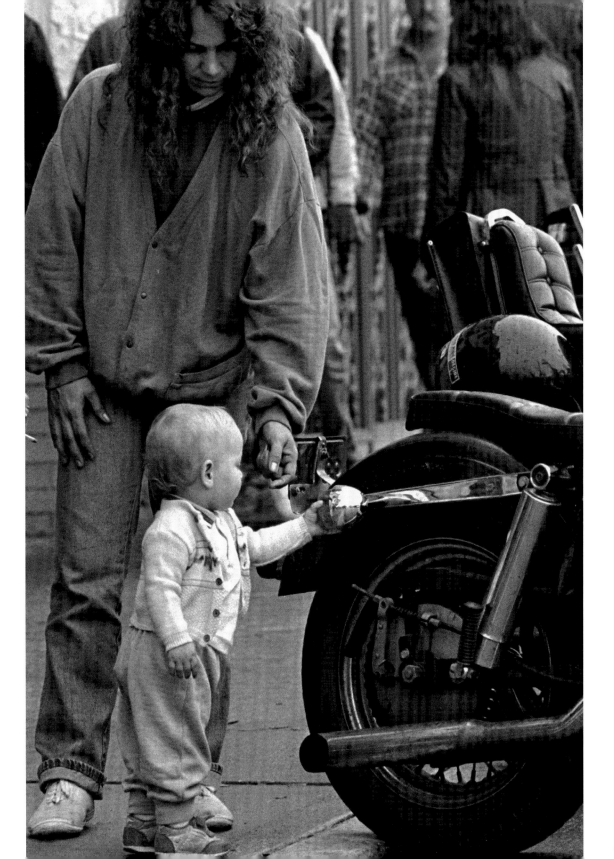

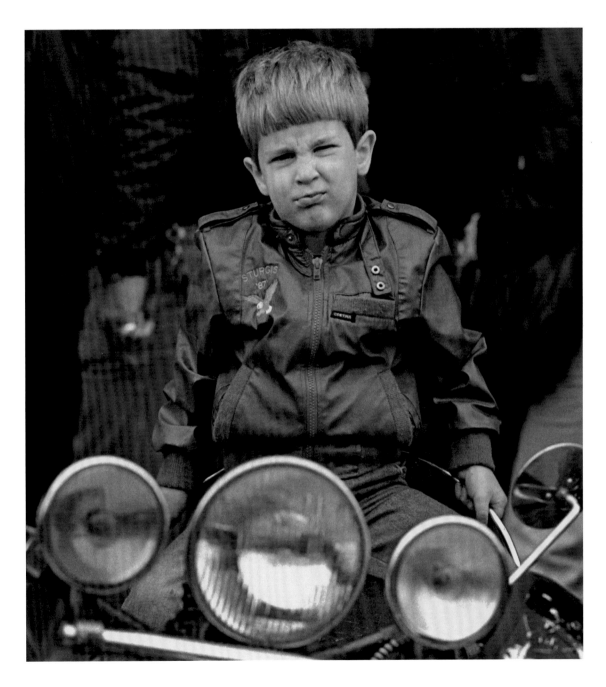

*Biker Boy 1988*   **17**

Left: *Mother and Child 1988*

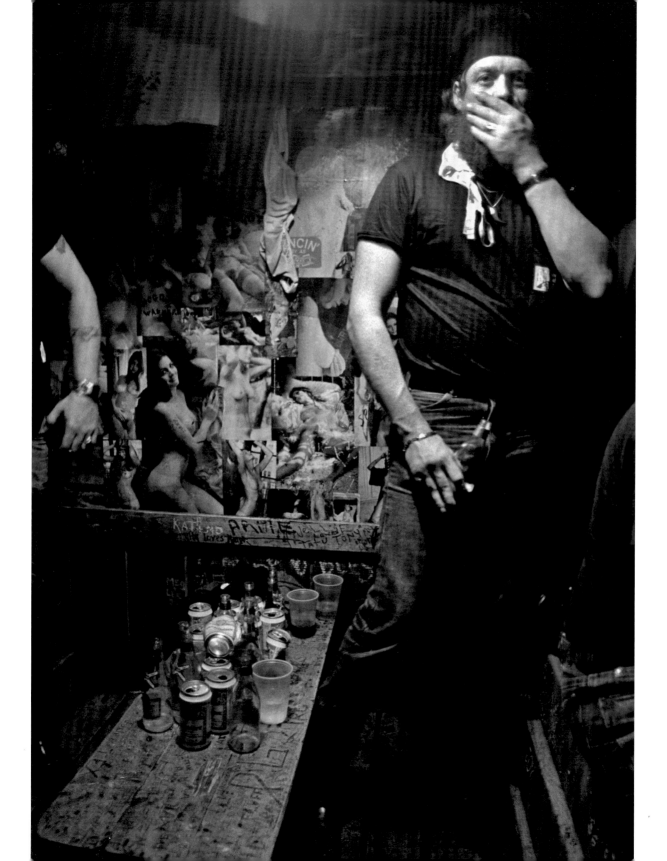

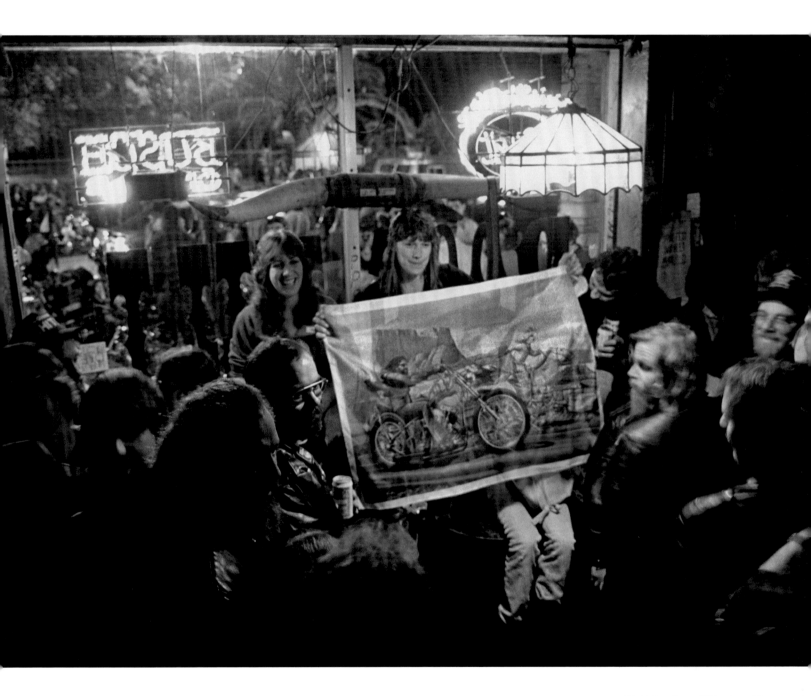

*Mythic Iron Horse 1988*     **19**
Left: *Boot Hill Booth 1988*

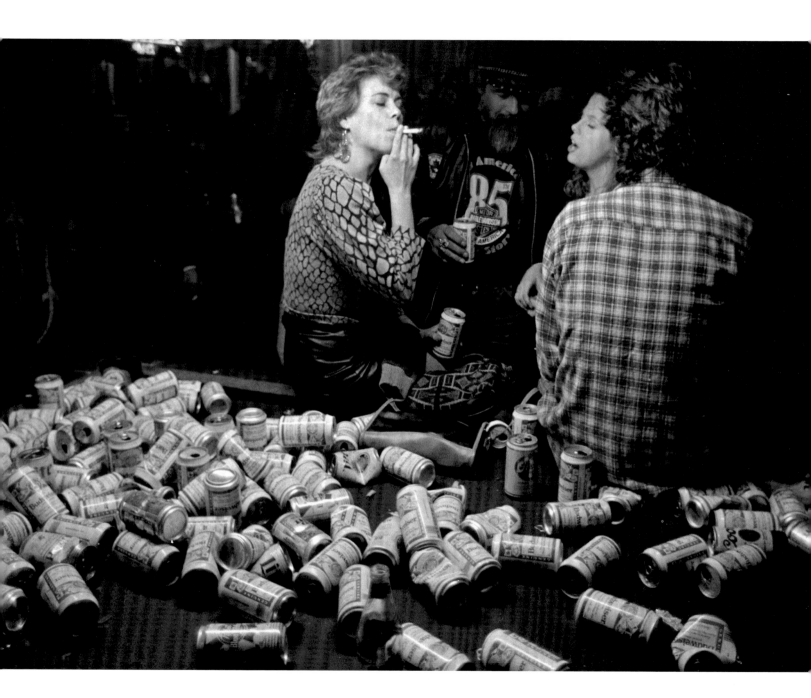

*Pool Table Closed 1989*

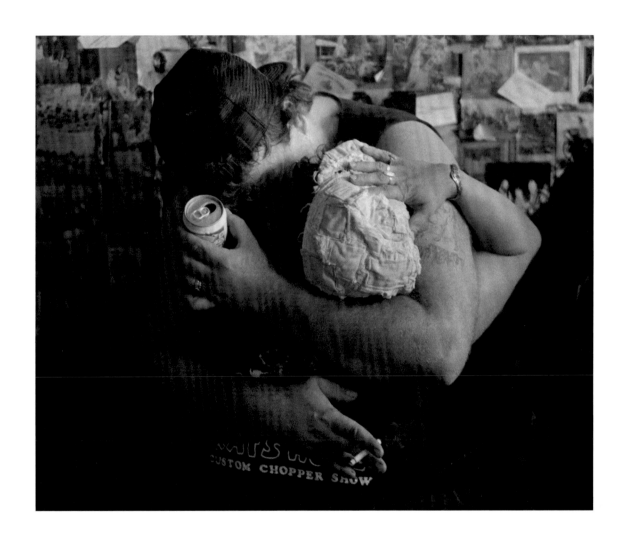

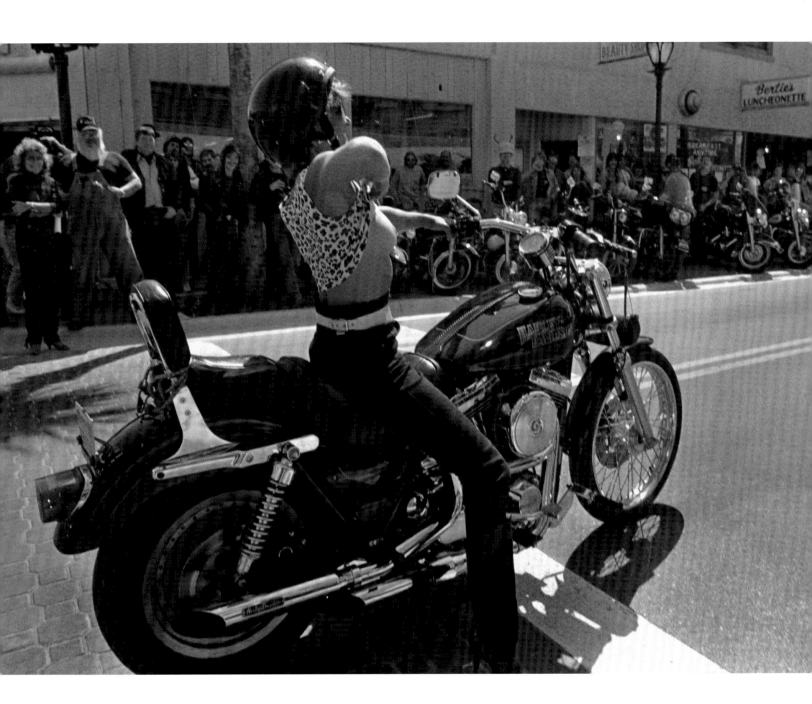

*Main Street 1989*

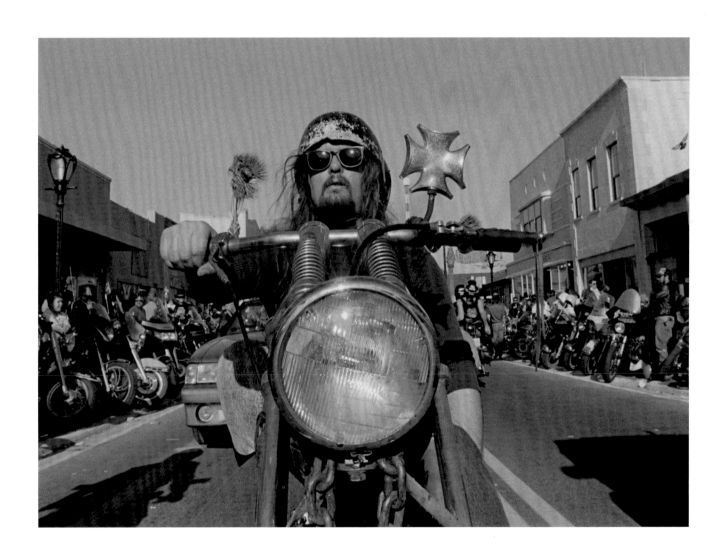

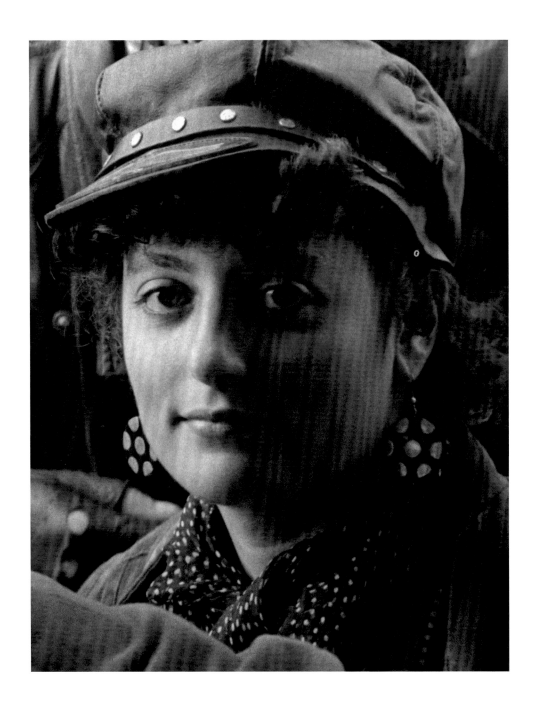

| *Entering the Boot 1989*

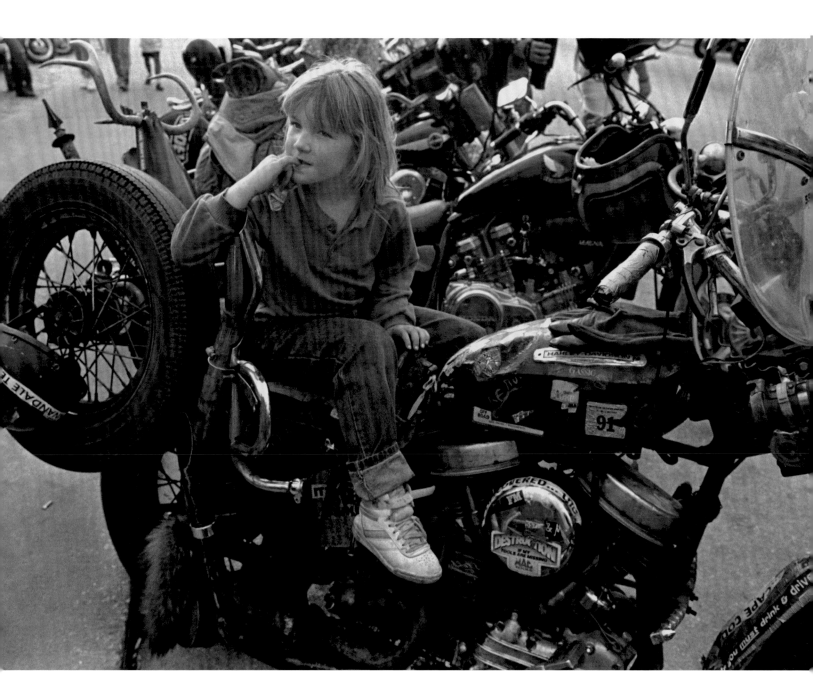

*Rat Bike and Girl 1990*

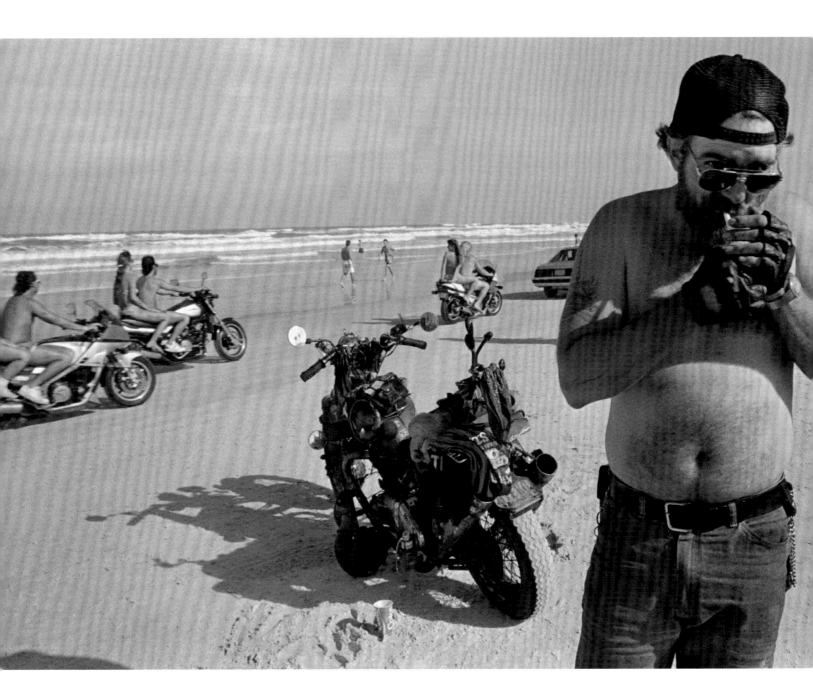

*Us and Them 1990*
Right: *Jesus is My Co-Pilot 1990*

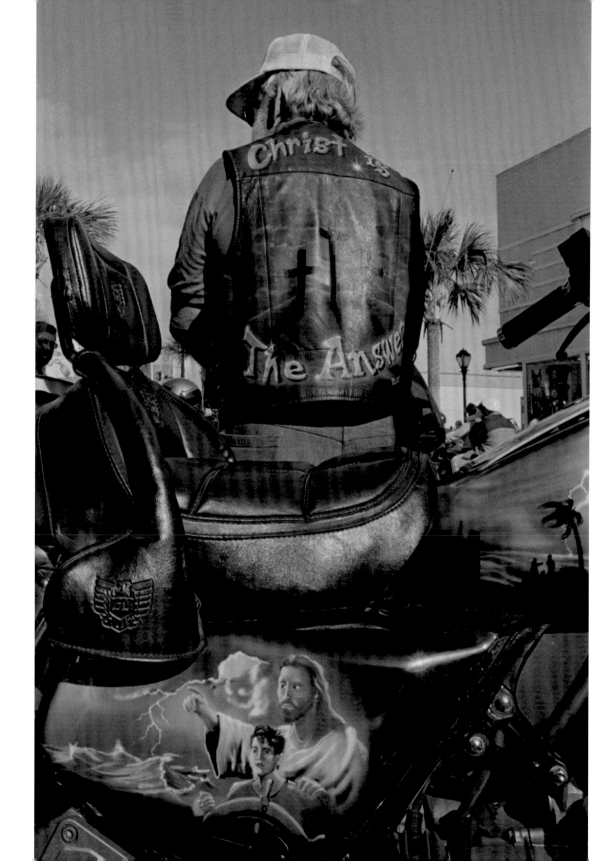

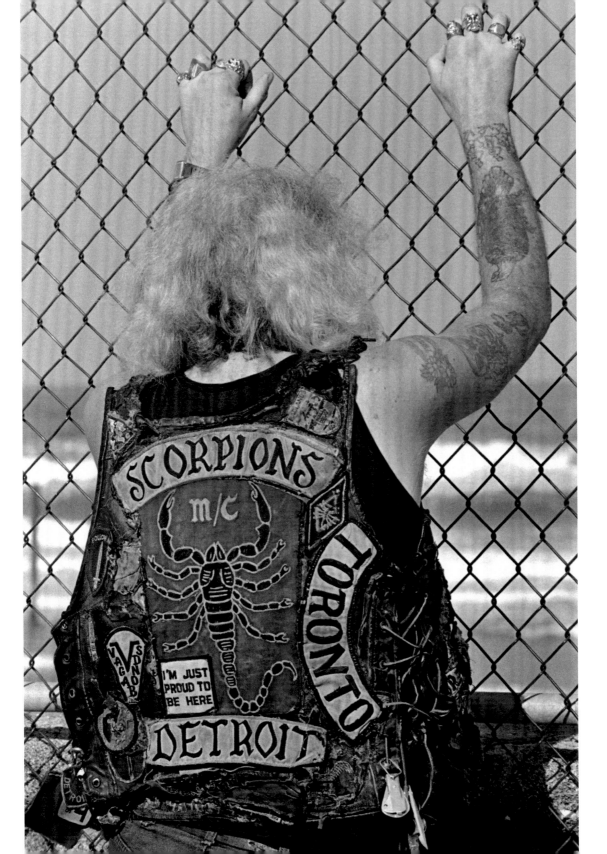

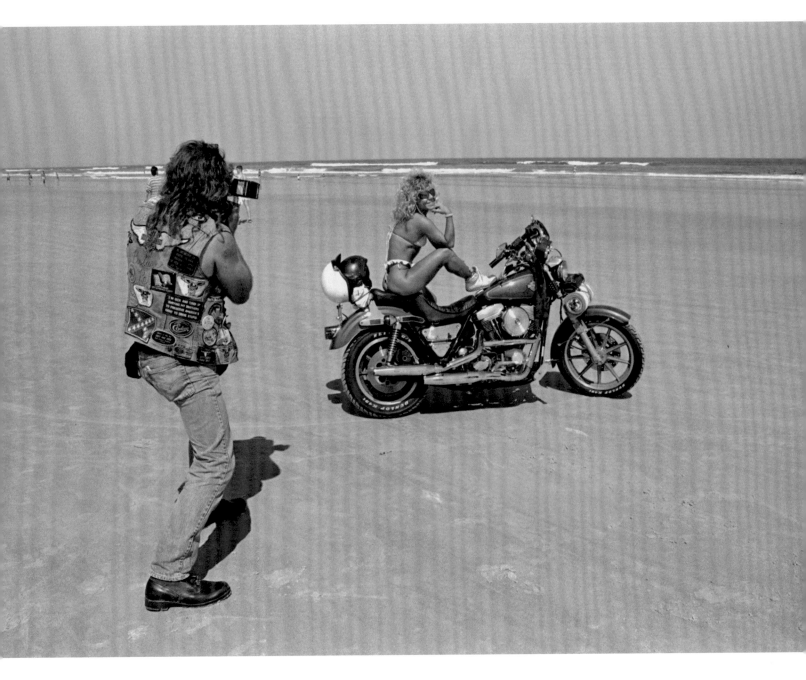

Left: *Over the Boardwalk 1990*

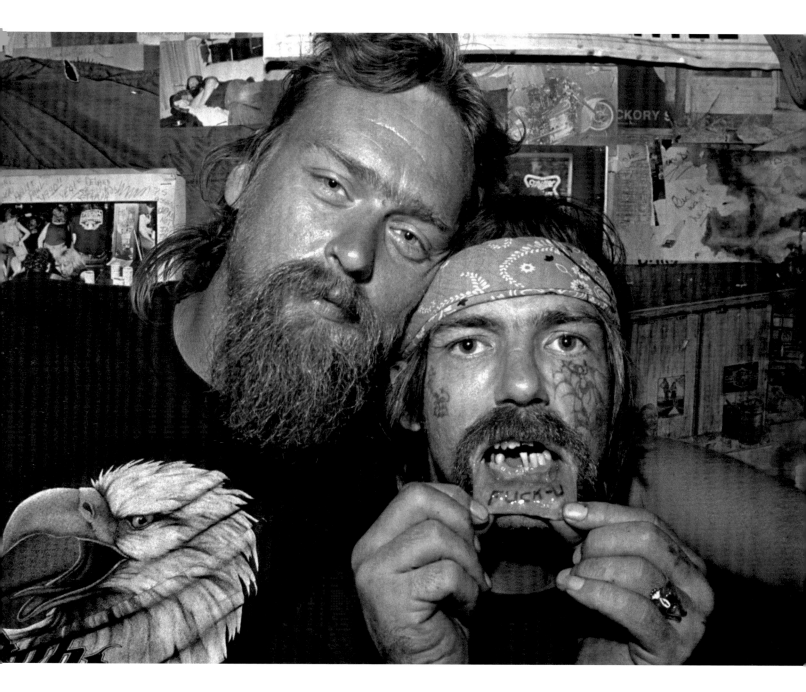

*Biker Brothers 1990*

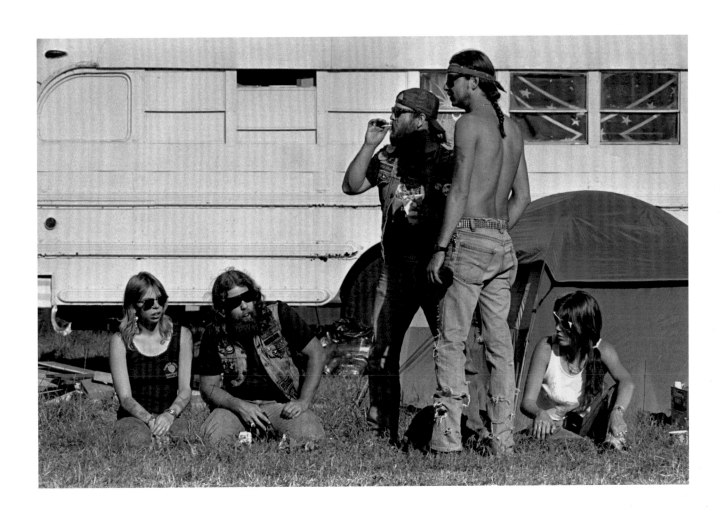

*Drag Race at the Cabbage Patch 1990* | 31

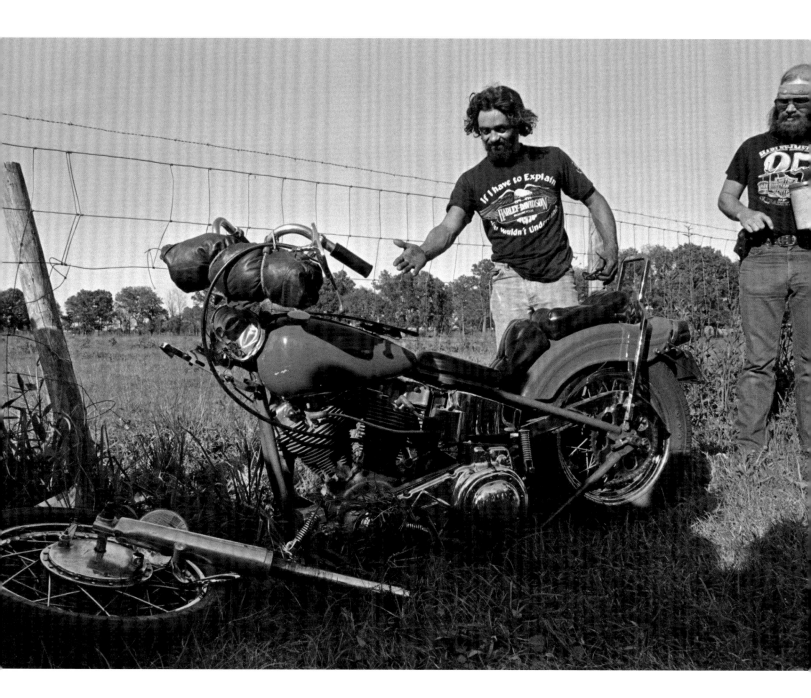

*Drag Racing Mishap 1990*

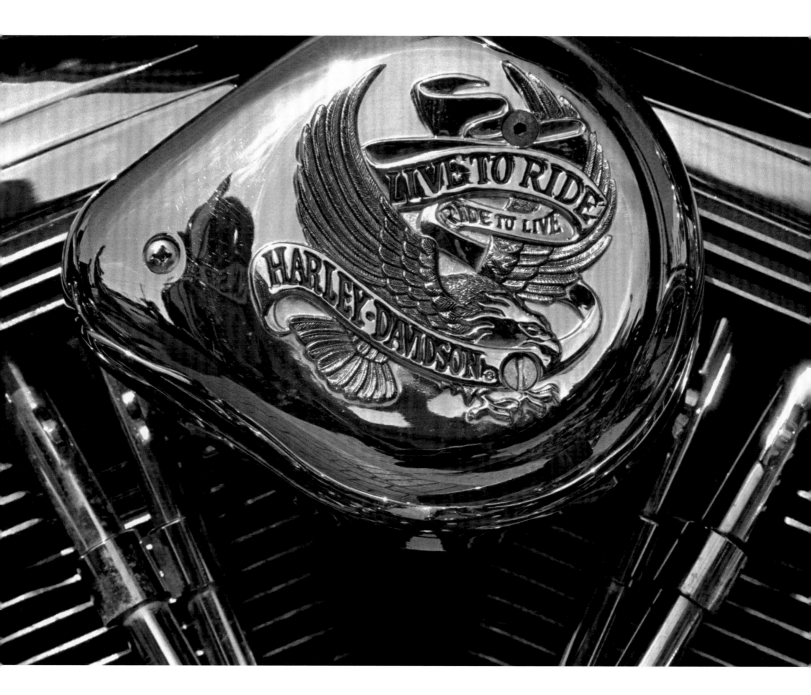

| *Harley V-Twin 1991*

# BIKERS

## and

# BOUTIQUES

**After a restful day with family Thursday, it was back on the bike Friday. Before heading for Daytona, however, I visited the local Harley dealership to get a smaller front tire.**

I recently had a front tire installed but had noticed that it was a little too close to the fender. The shop was abuzz with activity, due in part to the pre–Bike Week rush. The scene was also somewhat chaotic because it happened to be the shop's final week at that location, as they were preparing to move to a larger facility several blocks away. This has been a rather common occurrence among Harley-Davidson dealerships in recent years: small old greasy dens have been replaced by expansive and luminous bike boutiques, as many have taken to calling them.

I got a look at the new store a couple weeks later when I passed back through St. Petersburg during the course of my two-week tour of Florida after Bike Week. The contrast between the old shop and the new one is a fine illustration of the change that has come to Harley-style biking. Up to the 1990s, Harley-Davidson dealerships were far fewer in number and were much narrower in scope. The focus then was on motorcycles and motorcycle-related accessories such as oil, helmets, and black T-shirts.

The definition of motorcycle-related accessories has since broadened considerably. Now, next to the T-shirts there is a virtual department store of apparel and merchandise stamped with the Harley logo, from baby clothing and pet accessories to knickknacks and toilet seats. The service department is run less like an old filling station and more like the one at the Lexus dealership. As the Harley dealerships have relocated, they might now be found next door to the Lexus dealership.

Harley-Davidson's move uptown may be traced back to its 1981 separation from the New York–based conglomerate American Machine and Foundry (AMF). In an $81.5 million buyout, led by managers Vaughn Beals and William G. Davidson (grandson of one of the company's founders and known as Willie G. among the Harley faithful) and backed by Citicorp, the lone American motorcycle manufacturer returned to independence after twelve years of control by AMF.[1]

During the 1970s, the motorcycle industry had seen explosive growth. Unfortunately for Harley-Davidson, Japanese manufacturers were producing better-made, technologically superior, and less-expensive machines that appealed to the legions of young baby boomers who came shopping in the oil-crisis years of the 1970s. Additionally, Harley's persistent association with the outlaw biker image was not a plus for most of these new riders. Even Harley's traditional heavyweight turf was being invaded by the imports, such as Honda's 750-cc offering in 1970 and its 1,000-cc Gold Wing in 1975. Harley's 75 percent share of the U.S. heavyweight market in 1973 fell to 23 percent over the next decade.[2] Finally, Harley-Davidson's own rapidly increasing volume was accompanied by rapidly increasing quality problems that alienated dealers as well as customers and placed a stigma on "AMF Harleys" that persists today. In the long run, at least, the AMF era provided Harley-Davidson with plant modernization, improved management, and more sophisticated marketing.

Economic recession and continuing struggles against the Japanese competition posed serious threats to the newly independent Harley-Davidson Motor

Company between 1981 and 1985. Sales dropped, production was reduced, and its workforce was cut by 40 percent.[3] Having made significant quality improvements in the later AMF years, Harley now focused on improving management. The company also stepped up its marketing strategy for its traditional strength—heavyweight bikes.

In 1982, Harley-Davidson once again petitioned the International Trade Commission (ITC)—the third time since World War II—for protection against the Japanese imports. In response, President Ronald Reagan followed the ITC's recommendation by imposing a new tariff on heavyweight motorcycle imports. "The Reagan move benefited exactly one U.S. firm: Milwaukee's Harley-Davidson Motor Co.," said *Time* magazine. The move was designed to temporarily raise the price of Japanese motorcycles long enough for Harley to renew itself, although Honda and Kawasaki would partially dodge the tariff by shifting their bike production to U.S. plants.[4]

Other developments for the rebounding Harley-Davidson were measures of the company's strategy for success. The highly successful Harley Owners Group (HOG) was introduced in 1983, cleverly conceiving the group's acronym to read as the old Harley nickname "hog," which dates to the 1920s. Numerous HOG chapters organize meets and rides, providing an added link between company and customer. Harley-Davidson invaded the aftermarket by introducing its own Screamin' Eagle Performance Parts in 1983. Beals (now chairman) and Davidson (now a vice president) attracted publicity in the 1980s as they took part in various long-distance rides. These included an emancipative journey after the 1981 buy-out from Harley's home base in Milwaukee, Wisconsin, to its York, Pennsylvania, plant; a cross-country fund-raising ride for the Statue of Liberty in 1985; and in 1988 a series of cross-country rides converging in Milwaukee to celebrate the company's eighty-fifth anniversary and to support charity.[5] The new Evolution engine, in the works since the late-AMF years, finally arrived to replace the Shovelhead motor in 1984. With a stronger and more reliable new engine, by the mid-1980s it finally appeared that the company was getting back in shape.

Still in debt, however, in late 1984 Harley-Davidson was faced with the potentially fatal prospect of losing its financial support. Its lender, Citicorp, lacked confidence in the company's future and figured it would be best to discard it while conditions were relatively favorable.[6] Harley struggled to find other support after persuading Citicorp to grant it an extension. Finally, in late 1985 bankruptcy was narrowly averted when Harley attracted the support of Heller Financial Corporation. It would not take long for Harley-Davidson to prove itself.

The Harley-Davidson Motor Company went public with a listing on the American Stock Exchange in 1986. The following year, the company requested that its five-year tariff protection be lifted a year early. "We asked for help, we got it, we don't need it anymore, and in our simple Midwestern minds, it's time to give it back," Beals said. The occasion was marked by a celebratory visit to the York plant by President Reagan. A couple months later, Harley-Davidson moved to the New York Stock Exchange and was welcomed in the business press as "an exciting bet and a symbol of how an American company can do battle with its Japanese rival." Profits steadily increased and, among heavy-

weights, Harley passed industry-leader Honda, as it captured 33 percent of the over 850-cc market in 1986.[7]

Harley-Davidson now offered a range of reliable heavyweight motorcycles, from the entry-level 883-cc Sportster, with its new Evolution-styled engine and inviting price tag of $3,995, to the big twins—the 1340-cc cruisers and touring models. The company found it profitable to tap the growing demand for nostalgia-influenced styling. The 1986 Heritage Softail loudly harked back to the 1950s, while the 1988 Springer Softail revived front suspension designs not seen since the 1940s. Throughout its styling, the company was careful to stick to certain basic elements that would remain true to the traditional Harley look and not offend longtime devotees. "It's almost like being in the fashion business," said Davidson. "They rank the Harley look right up there with motherhood and God, and they don't want us to screw around with it."[8]

By the end of the 1980s, Harley-Davidson's comeback was complete, although its prosperity was just beginning. In 1989, the company held 63 percent of the U.S. heavyweight market, up from 23 percent in 1983. The company now offered a line of "factory approved" custom parts and accessories, created an expanding line of "motor clothes" apparel, and procured licensing and manufacturing arrangements for a dizzying array of merchandise. Success also extended overseas, where sales climbed from 13 percent of Harley-Davidson's total revenue in 1983 to 31 percent in 1991. The company customized its sales approach for various overseas markets and began fostering the kind of customer relations success it had developed at home, particularly with the establishment of HOG chapters and rallies.[9]

Harleys were becoming particularly popular in Europe and Japan.

Harley-Davidson's roaring success soon resulted in its supply falling well short of demand. Given the lessons learned when AMF-led Harley dramatically raised production to keep up with the rising demand of the early 1970s, resulting in serious quality problems that smeared the company's reputation, Harley was careful this time not to increase output too fast. But increase it did, from 55,000 motorcycles in 1989 to 105,000 in 1995. Harley's trailing supply, meanwhile, had the effect of frustrating impatient customers, encouraging high dealer markups, contributing to the increased value of new and used bikes, and adding yet more mystique to a product that already seemed to define the term. If the company could not please all of the people, it went on trying to please more of the people. A third manufacturing plant opened in Kansas City in 1998 to help meet the soaring demand. Production rose from 132,000 bikes in 1997 to 177,000 in 1999.

Seeking to follow Harley-Davidson's successful ride into the booming heavyweight motorcycle market, several new American manufacturers came on the scene in the 1990s.[10] Establishing the first homegrown competition for Harley-Davidson in four decades, these included Big Dog Motorcycles, Victory motorcycles by recreational vehicle-maker Polaris, and the Titan Motorcycle Company. Indian and Excelsior-Henderson, long dormant but esteemed names from an earlier era, also returned to compete once again with Harley-Davidson. Not incidentally, all of the start-ups were using large V-twin engines like those found on Harleys.

While these companies struggled to gain a foothold in the market, the real competition continued to come from Japan. Honda, Kawasaki, and others focused more on Harley look-alikes built around large V-twin engines, albeit with more technology and at lower prices.[11] Too much technology, however, misses the point for many Harley devotees, which is a traditionally raw motorcycle unencumbered by too many technological modifications. Of course, what technology is acceptable and what oversteps the bounds of propriety varies by rider and over time. Nevertheless, the Harley-Davidson stands alone for many as the definition of a motorcycle. "The Harley audience is granite-like, and most buy on emotional and lifestyle issues," said a competing executive.[12]

While styling is very important, as Harley-Davidson's design successes attest, a significant element of Harley-Davidson's mystique is "that slow, loping, distinctly Harley sound," as *Esquire* magazine described it. "People buy Harleys because of the look, sound, feel, reputation," said a brokerage analyst, predicting Harley's staying power against its challengers. The sound was described as "that 'potato-potato-potato' growl" by another writer. Another described it as "a basso-profundo thump from its big V-twin engine that [makes] other motorcycles sound like sewing machines."[13] Well informed to such sentiment, Harley-Davidson tried, unsuccessfully, to patent the sound of its engines in the late 1990s. The company also made sure, when it unveiled the successor to the Evolution engine in 1999, that the new 1,450-cc Twin-Cam 88 retained the traditional V-twin design and the distinct Harley sound.

In mid-2001, Harley rolled out the V-Rod, its first liquid-cooled motorcycle—technology long standard on foreign bikes. Even before it was introduced, some riders, with a hint of suspicion toward the new technology, were suggesting the nicknames "Watermelon" and "Sprinklerhead." Press reports played up the dissenting voices of "old Hells Angels types" and other "loyalists" who apparently considered the bike a "sacrilege and the end of an era." Beyond the sensationalistic leads and reactionary responses, however, talk both in the press and on the streets turned to a more sober consideration of how Harley-Davidson was seeking to adjust to market changes and broaden its appeal for the future. With liquid cooling and other initiatives, Harley-Davidson had to introduce new and different designs and technology without upsetting the faithful.

In 1999, "Harley eclipsed Honda as the number one seller of motorcycles in the U.S. market for the first time in three decades," reported *Forbes* magazine. In the over-651-cc range for the year 2003, Harley-Davidson/Buell commanded 48 percent of the North American market (second-place Honda's share was 19 percent), ranked sixth in Europe with about 8 percent of the market, and had a leading 26 percent share in the Asia-Pacific market.[14] Buell Motorcycle Company, producer of sport motorcycles and founded by a former Harley engineer in the 1980s, was acquired by Harley-Davidson, Inc. in 1998. In 2003, Harley-Davidson produced 291,147 motorcycles for the year of its hundredth anniversary, plus 9,974 Buell motorcycles, combining for a 10 percent increase over 2002.

Harley-Davidson set production targets of 317,000 bikes for 2004 and at least 400,000 bikes by 2007. Recall that the company produced 36,735 bikes in 1986, near the start of its resurgence. Total net sales of bikes, parts and accessories, and merchandise stood at

$4.6 billion in 2003, up 13 percent from 2002; net income in 2003 stood at $761 million. Worldwide membership in the HOG reached 840,000, up from about 150,000 a decade earlier.

Harley-Davidson's recovery in the 1980s and 1990s was not entirely unique, as the American automobile industry enjoyed a similar comeback against its Japanese competition during the same period. While Harley has succeeded by selling its big motorcycles, large sport utility vehicles have been a particularly successful section of the four-wheeled market. But this is not simply a business story. Throughout its highs and lows in the motorcycle manufacturing business, Harley-Davidson has made a highly visible cultural impression, both within and outside the United States. It is an icon solidly connected with American ideas about freedom and rebelliousness.

Motorcycles have long attracted rebellious spirits who like to push the edges of normality. Ever since the 1920s, when cars first presented an economical and practical alternative, motorcycles—with little space and little protection—have largely been relegated to the frivolous. It was only after World War II, however, that the boundaries were pushed so far as to create a deviant, and sometimes criminal, motorcycle subculture.

For some veterans returning from the war to the prospect of a relatively staid civilian life, a more attractive alternative seemed to lie in continued restlessness aboard motorcycles with their peers. This development resulted in a deviant image that stood in stark contrast to the predominant spirit of conformity in postwar America. Whatever the extent of actual lawbreaking, the outlaw image would be magnified, sensationalized, and popularized over many years in the

mass media, and it would ultimately shape the perception of motorcycling for decades.

The new, bedraggled wave of bikeriders, as they were sometimes known in these early years before the term "biker" spread from California and into common use, arose in contrast to the traditional, neatly outfitted bike clubs from the 1930s.[15] Throughout the 1950s and 1960s, the Harley-Davidson Motor Company would steer clear of the ever-growing outlaw image and instead promote its motorcycles in accordance with the image of law-abiding, Main Street America. Nevertheless, Harley-Davidsons were popular among bikers, and the brand would become closely connected to the outlaw image.

There is widespread consensus that a seminal biker moment arrived over the Independence Day weekend in 1947 in Hollister, California. A routine motorcycle rally evolved into general mayhem, with drag races through town, fights, public intoxication, and indecent exposure. About fifty arrests were made, roughly another fifty people were treated for minor injuries, and several riders were more seriously injured while attempting stunts. A few weeks later, *Life* magazine published a nearly full-page photograph of an apparently drunken participant astride a Harley-Davidson motorcycle, with beer bottles littering the curb beneath him. No story accompanied the photo, but there was a paragraph-long caption describing the melee.[16]

Some debate has occurred over whether the photograph was set up and the extent to which *Life* exaggerated its report, but the photograph seems a mild representation of the event, given particular undisputed facts. As for the text of the report, the magazine

apparently overstated the number of riders participating in the disturbance and misleadingly implied that only motorcyclists were involved. Details aside, more significant is the mere fact that the nationally prominent magazine publicized the Hollister event to its broad audience and for posterity. Never mind that, three weeks later, *Life* published three letters to the editor that challenged the sensationalist tone of its coverage, along with a four-page "presentation of law-abiding, respectable motorcyclists," ostensibly to counterbalance its earlier report.[17]

*Life*'s coverage might have passed into obscurity and Hollister might have been forgotten but for a chain of events that would continue to draw attention to the emerging biker subculture and eventually lead to a retracing of events back to Hollister. A few years later, *Harper's* magazine published a fictionalized account of the Hollister story, made grimmer by having a motorcyclist recklessly run down and kill a local young woman inside a hotel lobby.[18] A few more years later, this story was translated to the big screen in 1954's *The Wild One*. This Hollywood version had Marlon Brando's antihero, far from killing the young woman, allowing her a romantic peek behind his hardened facade. But Brando didn't get the girl; instead, he eventually rode off on his sullenly dissociated way.

*The Wild One* may have softened the story line, but it nonetheless magnified for the public the image of the biker menace. "'The Wild One' elaborated on the Hollister event and drew upon the subsequent barrage of reporting and publicity to establish an image that confirmed the postwar identity of the biker," according to Art Simon, guest curator for the Guggenheim Museum's 1998 exhibit, The Art of the Motorcycle.

This image identified bikers as "rebels for a vague individualism, potential outlaws, and sexual predators."[19]

The postwar biker was a new phenomenon and one well suited to California's temperate climate. A half century after the last Wild West outlaws and mavericks roamed the range on horseback, gangs of city-dwelling bikers were mounting their iron horses and riding off to far-flung small towns, disturbing the locals and clashing with the law. "Like the drifters who rode west after Appomattox, there were thousands of veterans in 1945 who flatly rejected the idea of going back to their prewar pattern," wrote Hunter S. Thompson in his *Hell's Angels: A Strange and Terrible Saga*. "They wanted more action, and one of the ways to look for it was on a big motorcycle."[20]

Of course, bikers themselves were among those watching *The Wild One*, and the movie and other media representations no doubt contributed to the shaping of their self-image as bikers.[21] In an essay on motorcycles in film for the 1998 Guggenheim motorcycle exhibit, Ted Polhemus noted that the biker "subculture largely derived its vision of itself from the cinema, and here was a fertile field from which sprang visions of the outlaw as gutsy individualist, if not hero." Thompson quoted a lifetime Hells Angel on his viewing of the film. "There were about 50 of us, with jugs of wine and our black leather jackets. . . . We sat up there in the balcony and smoked cigars and drank wine and cheered like bastards," the Angel said. "We could all see ourselves right there on the screen. We were all Marlon Brando," he added. "I guess I must have seen it four or five times."[22]

Emerging outlaw groups such as the familiar Hells Angels Motorcycle Club (HAMC) provided the real-life

kernel of truth for the media's promulgation of the negative biker image and, at the same time, its unintended promotion of an intriguing biker mystique.[23] Amid the conformity of the 1950s, writes Polhemus, the romantic vision of a carefree individualist throttling his bike down an open road "may have sent shivers of fear and loathing down the spine, but more often than most cared to admit, they were accompanied by shivers of longing and desire."[24]

Most motorcyclists, and many "bikers" as well, were not outlaws. But the outlaw image subsumed the others, especially those who identified with and adopted the rebellious image, even if they were never inclined toward actual lawbreaking. In the Hollister aftermath, the American Motorcycle Association (AMA) sought to redeem the image of law-abiding motorcyclists by issuing the statement that "only one percent of motorcyclists are hoodlums and troublemakers."[25] In defiant response, outlaw club members began the tradition of proudly referring to themselves as "one-percenters." By drawing a line between the law-abiding and the lawbreakers, the AMA effectively labeled the outlaws, contributing to the definition of their deviant self-image.

The Hells Angels emerged from San Bernardino, California, about 1949. A San Francisco HAMC chapter opened in 1954. In these earlier years, biker clubs often had a partly bohemian flavor. But by the 1960s, when the beatniks became hippies, bikers were going their own way. The rising Oakland chapter of the HAMC exemplified this different course. "The original Oakland Angels were hard-ass brawlers—a purer strain, as it were—and they had never made contact with the jazz, poetry and protest element of Berkeley

and San Francisco," Thompson wrote.[26] These bikers were more likely to knock heads than knock the establishment. It was this strain of biker that went on to capture a renewed public spotlight in the mid-1960s and serve as the basis for the enduring image of the biker as deviant miscreant.

Thompson's 1967 book documents the few pivotal years for the Hells Angels in which they were showered with media attention and lifted to national prominence. As chronicled by Thompson, an alleged rape by several Hells Angels over the Labor Day weekend in 1964 triggered the exposure. The charges were dropped, but the incident prompted a six-month investigation by California's attorney general. The ensuing report resulted in stories on the Hells Angels in major newspapers across the country as well as in *Time*, *Newsweek*, and the *Saturday Evening Post*.[27]

Appearing on television and radio, the Angels were met with fascination by some and became minor celebrities in the radical political climate of the time. "The long-dormant Hells Angels got 18 years' worth of exposure in six months, and it naturally went to their heads," Thompson noted. "One day they were a gang of bums, scratching for any hard dollar . . . and twenty-four hours later they were dealing with reporters, photographers, free-lance writers and all kinds of showbiz hustlers talking big money."[28]

If some might have expected the biker subculture to slowly dissolve or remain marginalized and inconsequential, instead it was now being born again as a deviant institution. This development may be interpreted as an effect of any or all of the following: the aforementioned increase in media attention; the widespread rebellious spirit of the flourishing countercul-

ture; the coming-of-age baby-boom generation, which served both to deepen the biking ranks and as an attractive target audience for more media portrayals; the Vietnam War, alienated veterans of which took to two wheels as did their predecessors following World War II; and, of course, the activities of the bikers themselves.

For the Hells Angels, riding at the front of the biker subculture, these activities included exploiting media interest, associating with celebrities, incorporating itself, patenting its name and death's-head logo, and not least, engaging in illegal behavior—particularly using and dealing drugs.[29] The Hells Angels, among other outlaw clubs such as the Outlaws and the Pagans, in the next few decades would see considerable growth in membership and sophistication throughout the United States, Canada, and overseas. Indeed, the Hells Angels have long been recognized as being among the largest organized criminal networks.

The biker subculture at large became firmly established in the outlaw image following its 1960s growth spurt. This image would continue to exert a strong influence on the public's perception of all motorcyclists for many years to come. This was especially so for Harley-Davidson riders, as bikers had long favored the big, American-made Harleys. Some European brands were acceptable—after all, Brando rode a British-made Triumph in *The Wild One*. Japanese motorcycles, rising to market prominence through the 1960s and 1970s, were not considered biker material.

After the success of the 1969 film *Easy Rider*, in which Harley-riding hippie-bikers were presented in a relatively more favorable and complex light compared to previous portrayals, the biker image—outlaw clubs notwithstanding—began its long, slow transformation toward nondeviance and respectability. Other early signposts along this road included a short-lived *Easy Rider*–like television series titled *Then Came Bronson*; a portrait of the philosopher-biker in the popular 1974 book *Zen and the Art of Motorcycle Maintenance*;[30] the celebrity of Harley-riding daredevil Evel Knievel; and, at the Harley-Davidson Motor Company, the development of the Super Glide motorcycle.

The 1971 Super Glide was the first of Harley-Davidson's "factory customs," machines inspired by the wild customization then growing in popularity among bikers. With this model, the company ended its long-standing rejection of the biker subculture, instead tapping into this faithful customer base. The pared-down Super Glide, straight out of the showroom, was already well on its way to being a sleek chopper of the sort favored by bikers, fostered in the growing aftermarket and popularized through the mass media. Indeed, the Panhead ridden by Peter Fonda's character in *Easy Rider* became an icon among choppers and Harley-Davidsons in general. Other "factory customs" included the 1977 Low Rider and the 1980 Wide Glide. Although the Super Glide was not especially successful on its own, in setting the mold for "factory customs" to come, it established a direction for Harley-Davidson that eventually returned the company to prosperity.

Harley-Davidson's revival in the 1980s was inextricably interrelated with its gradually changing image. Even while Harleys were still connected with the image of the deviant biker, through the 1980s and into the 1990s more and more newcomers were choosing to

ride Harleys and bringing with them gradual change. Remarkably, the highway-cruising, chrome-laden machines were becoming positive icons of America and were increasingly serving as upscale status symbols. Where the outlaw image persisted, it was largely transformed from deviant to cool.

Mainstream America had managed to co-opt what for four decades had served as a potent countercultural and subcultural symbol. It took a lot longer in Harley-Davidson's case, but its motorcycles had finally followed the road to respectability traveled by blue jeans and rock and roll music, as well as later clothing and musical styles. "It's an irresistible story in a bull market: motorbikes have become a yuppie thing, and Harley's the prestige brand that people will pay up for," declared *Forbes* magazine in 1997. "Wall Street loves the Harley story."[31]

All things Harley were now available well beyond the company's blossoming bike boutiques. Corner drugstores offered Harley-Davidson motorcycle "keepsake ornaments" by Hallmark for the Christmas tree. From the Franklin Mint one could order a miniature Harley, complete with a red bandana–attired biker doll. For those with more money to spend, options included the widely touted Harley stock or speculation in one or more of the bikes themselves. Observing that the Harley-Davidson motorcycle itself was a fairly straightforward machine, *Esquire* magazine said its "stock is a buy because of the bike's free-spirit cachet and the truly mind-blowing magnitude of the market that image increasingly appeals to."[32]

That market was comprised of affluent, middle-aged men of the aging baby-boom generation, now in their thirties and forties. "The industry owes its health to the boomers," a motorcycle industry consultant told *Business Week* magazine in 1996. It was becoming increasingly common in the media and among bikers themselves to hear the comment that executives, doctors, and lawyers were now riding Harleys—in other words, not just gang members and other undesirables.[33] New York City's Harley-Davidson Cafe, perhaps the ultimate yuppie-biker bar, opened in midtown Manhattan in 1993, and the successful enterprise soon was duplicated in Las Vegas. In 1999, the company announced the construction of its $30 million "experience center" in Milwaukee, planned as a showcase for the Harley culture and lifestyle, with a restaurant and banquet facility, shopping center, and outdoor special events area.

It is to be expected that Harley-Davidson's success and the accompanying changes would be met with mixed emotions by longtime devotees. Many longtime riders, who may have been somewhat invested in the old biker image or for other reasons resented what the new image introduced, now had to adjust to what amounted to an invasion of their turf. In addition to derisively labeling the new dealerships as bike boutiques, some began referring to them as "stealerships" and calling the MoCo (Motor Company) "the MoFoCo." New black T-shirts appearing in Daytona Beach referred to Harley-Davidson as the "Greedy Bastards Motorcycle Company" and declared—against bountiful evidence to the contrary—the company deceased with "R.I.P. Harley-Davidson."

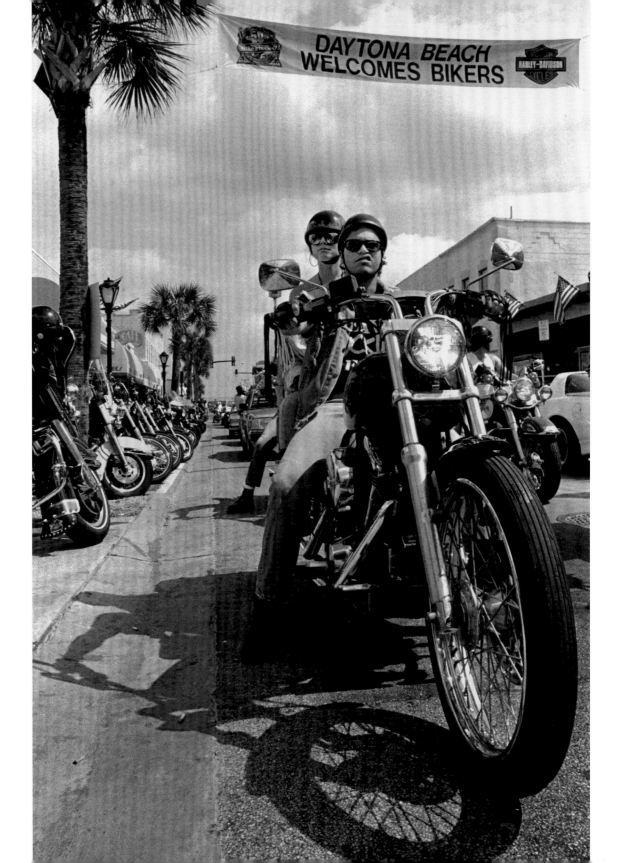

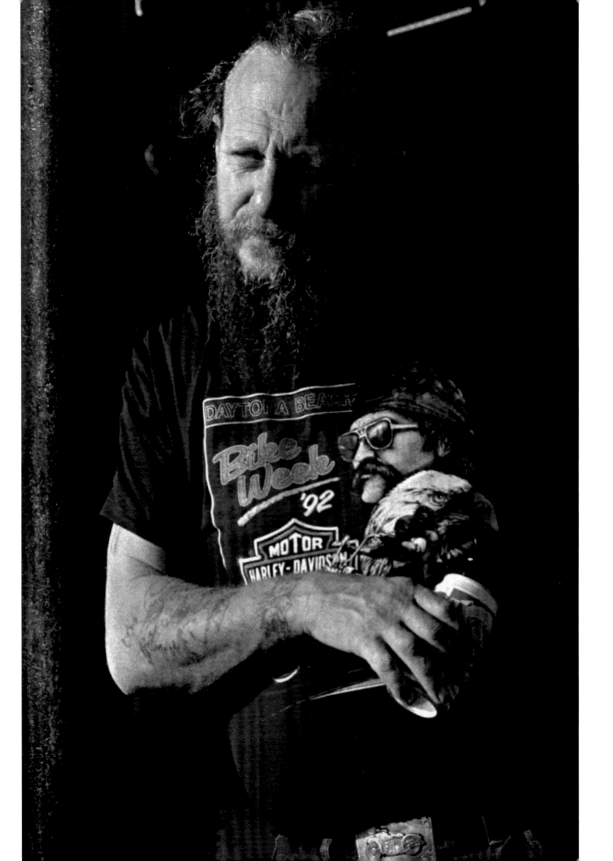

*Mud Wrestler Dakota Rose 1992*

*With Peter Fonda 1991*

*Easyriders 1992*

Right: *Main Street Exhibit 1993*

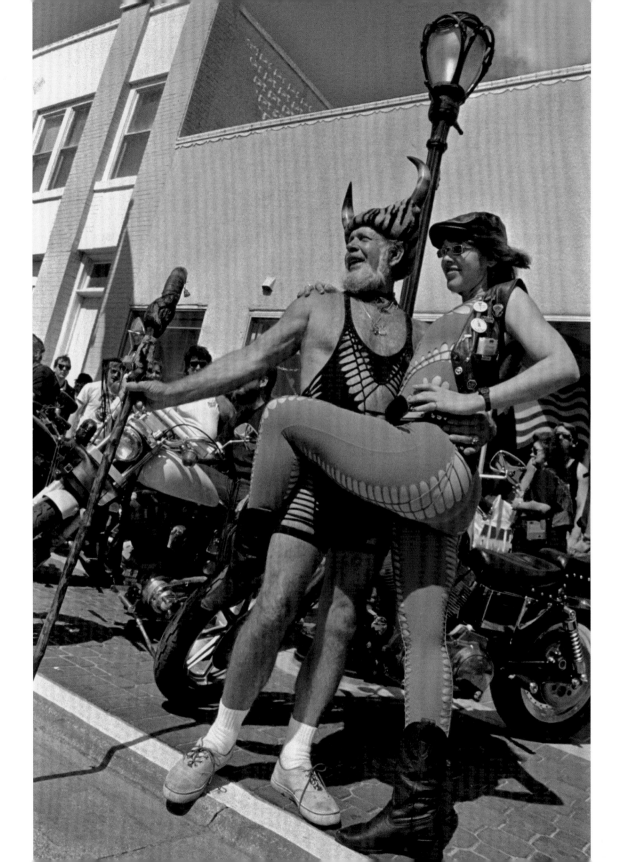

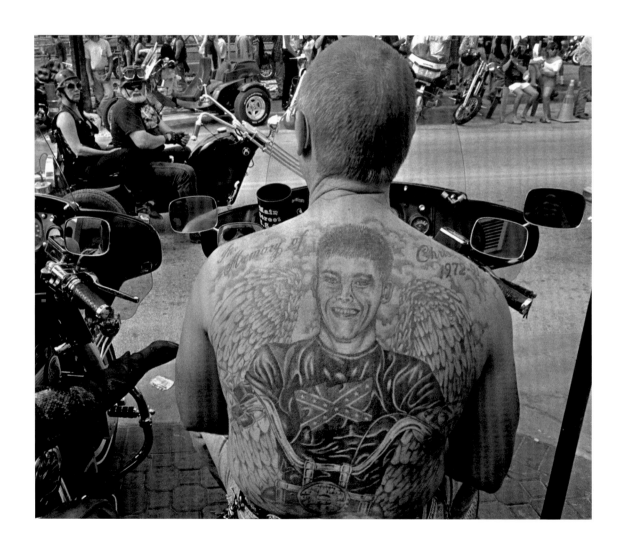

| *Memorial Tattoo 1994*

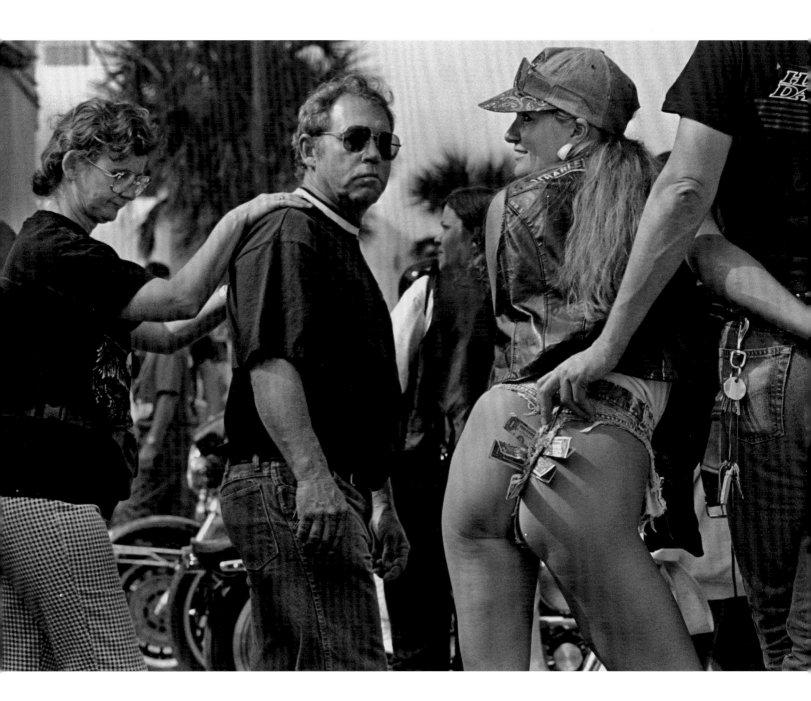

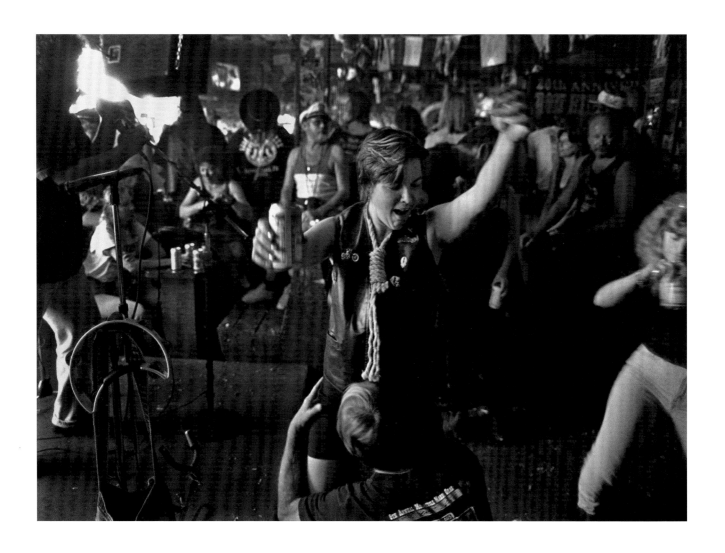

| *Boot Hill Dance 1994*

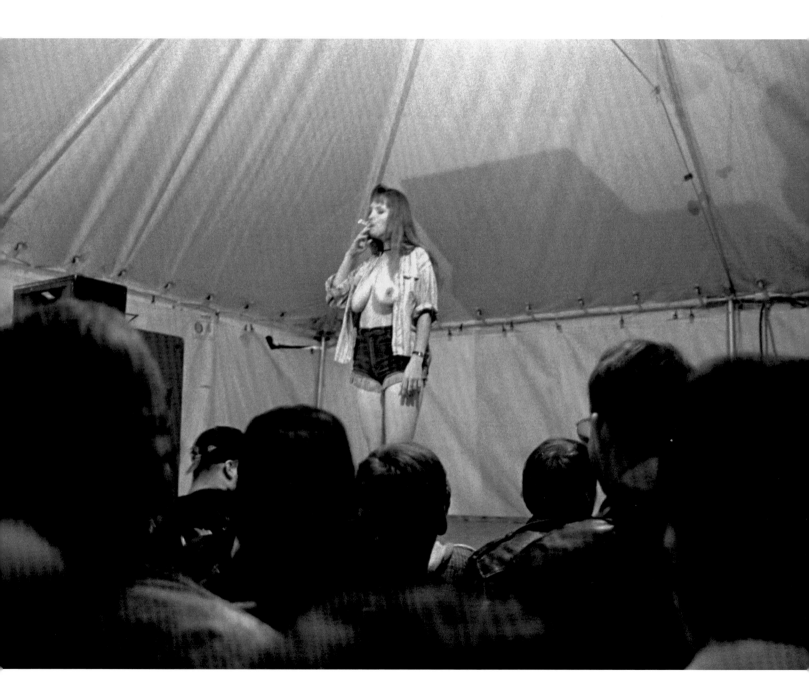

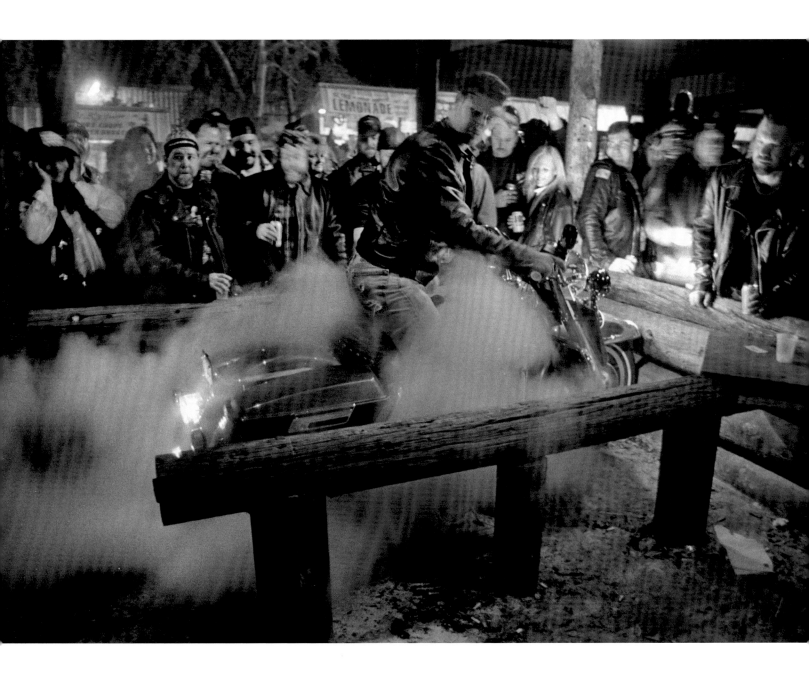

*The Burnout Pit 1996*

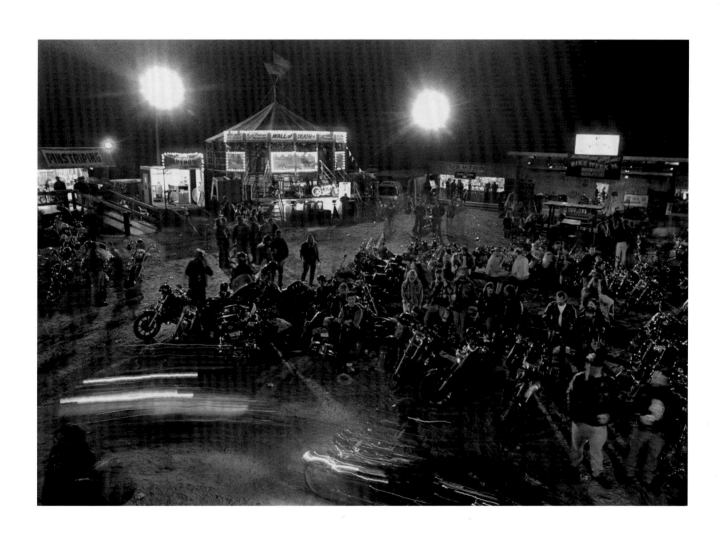

*Iron Horse Saloon 1996*   **57**

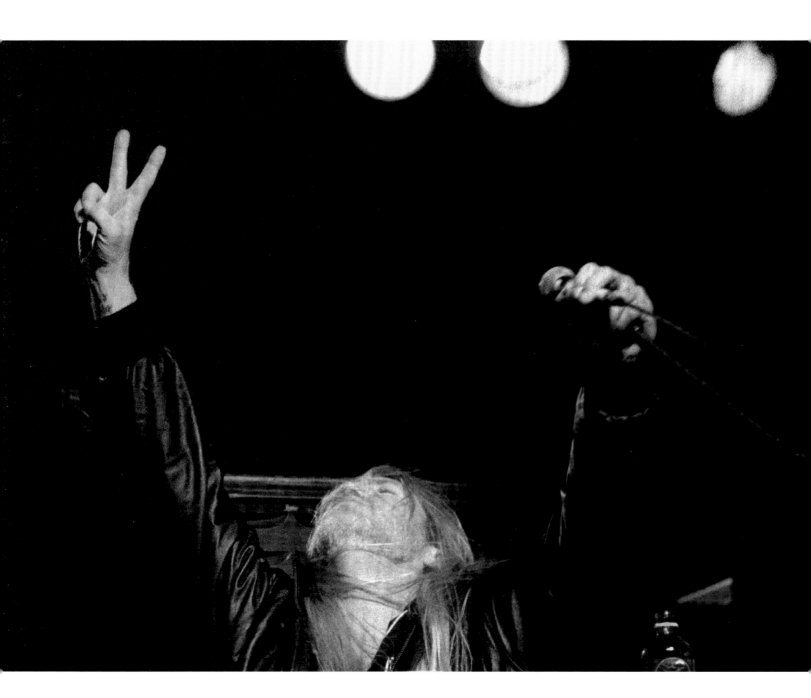

*Gregg Allman in the Park 1994*

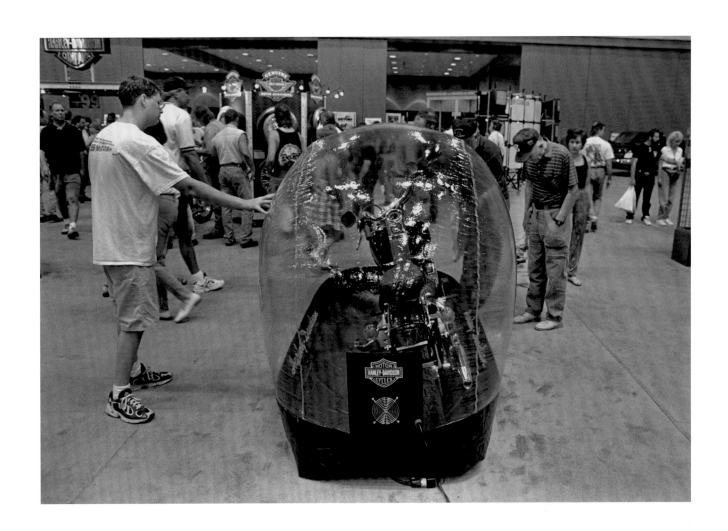

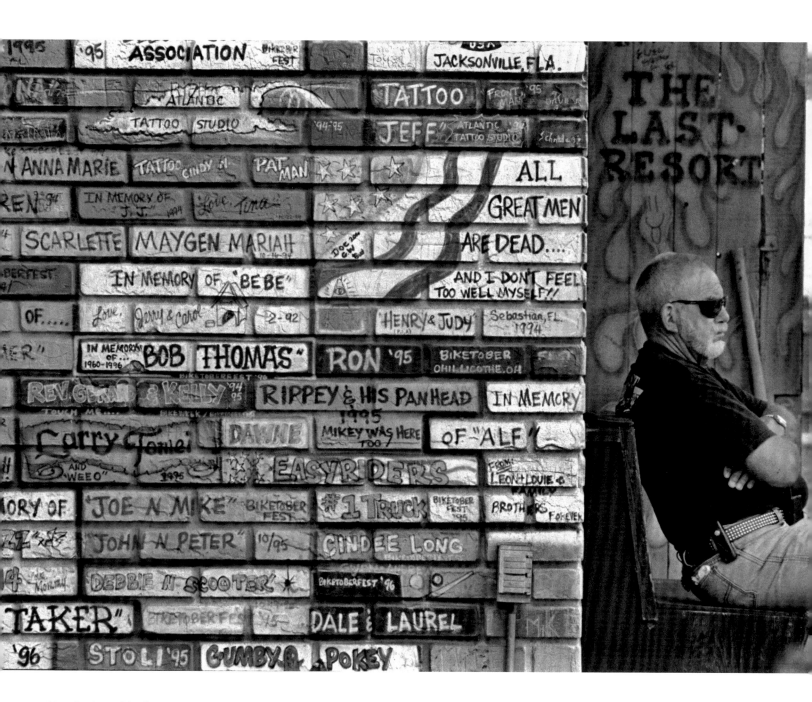

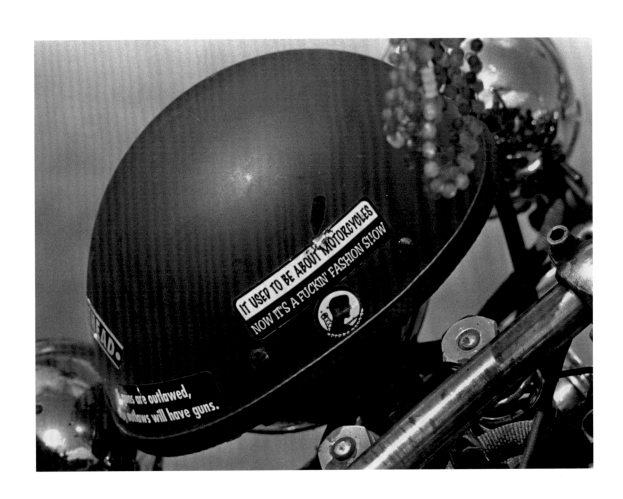

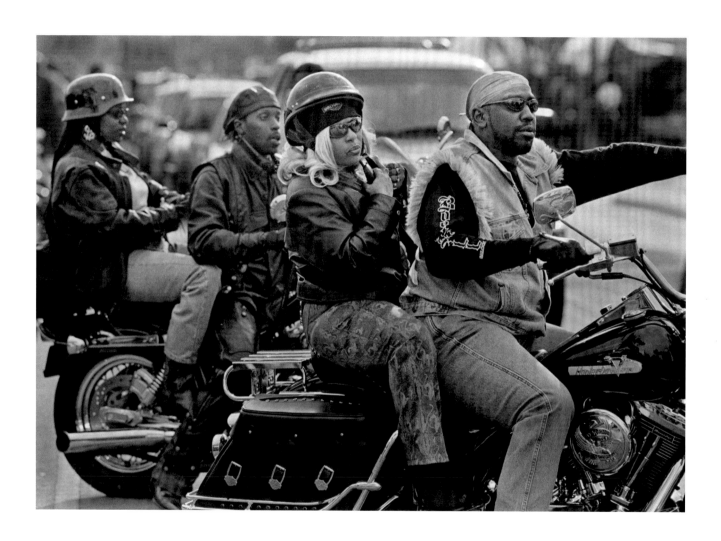

| *Bethune Boulevard 2001*

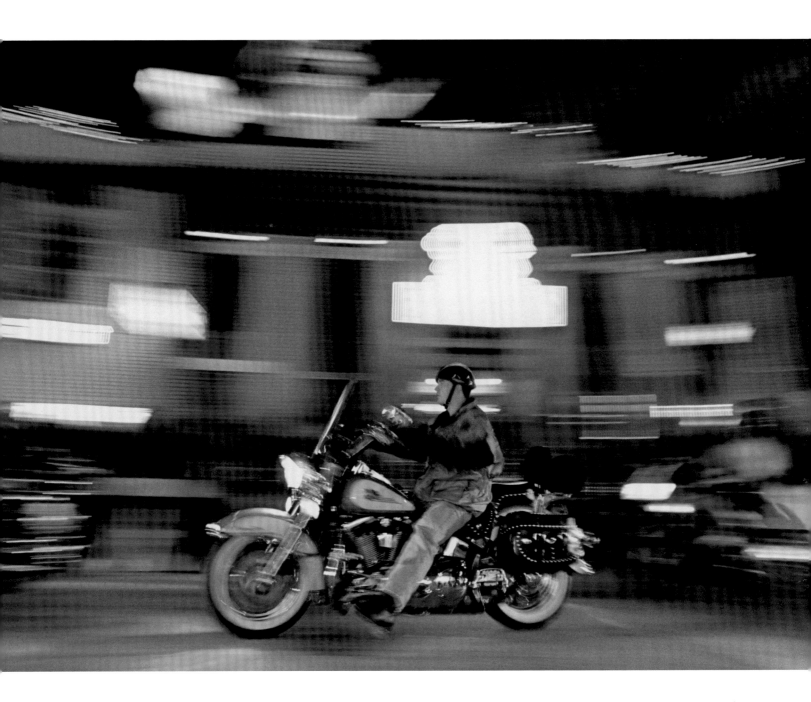

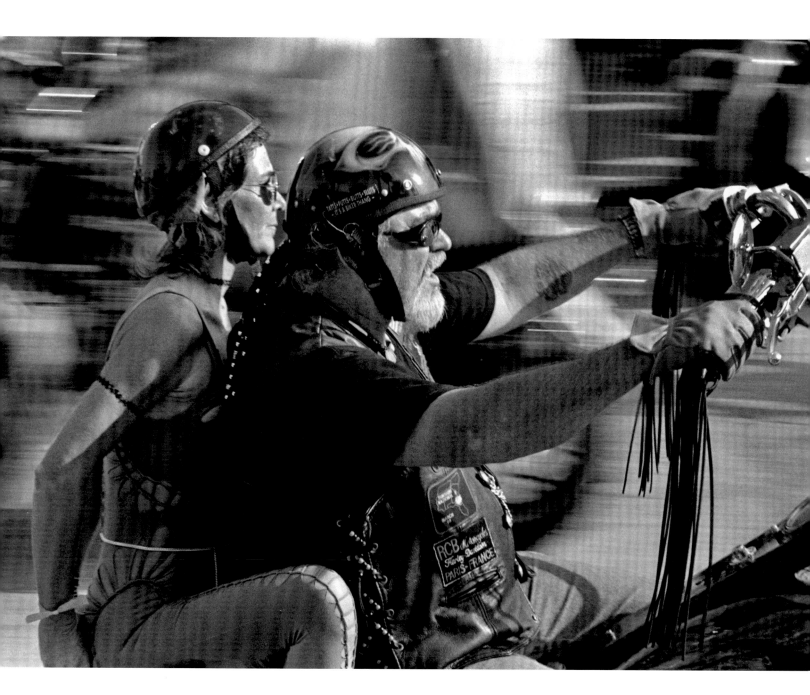

*Ride on Main Street 2000*

Right: *Just Married 2000*

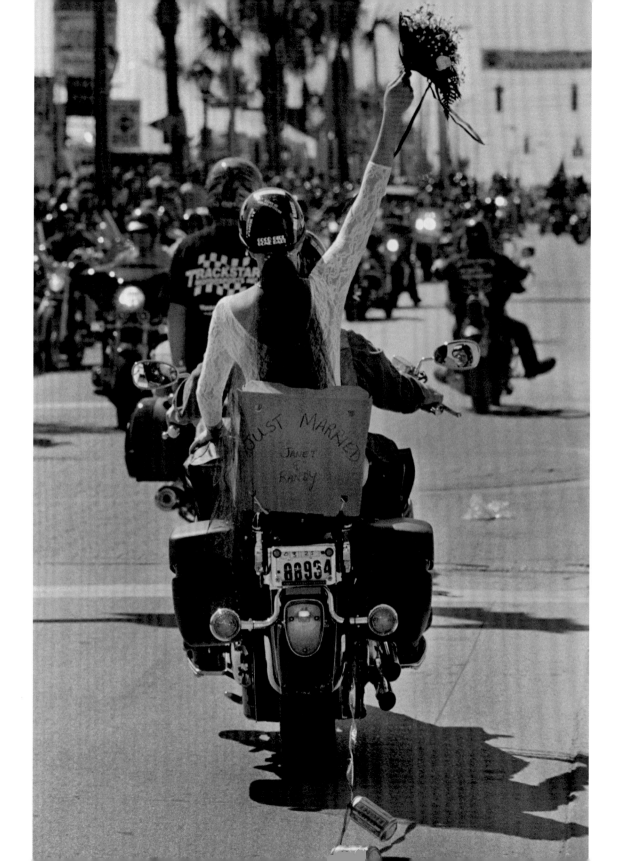

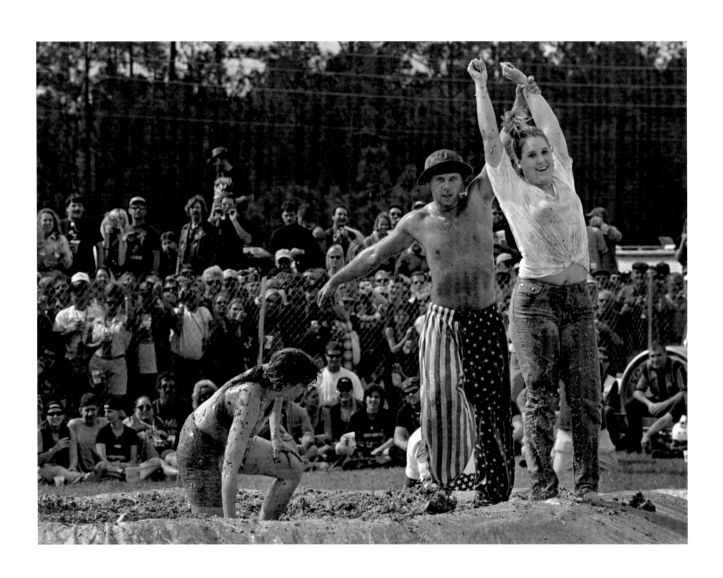

| *Cole Slaw Victory 1999*

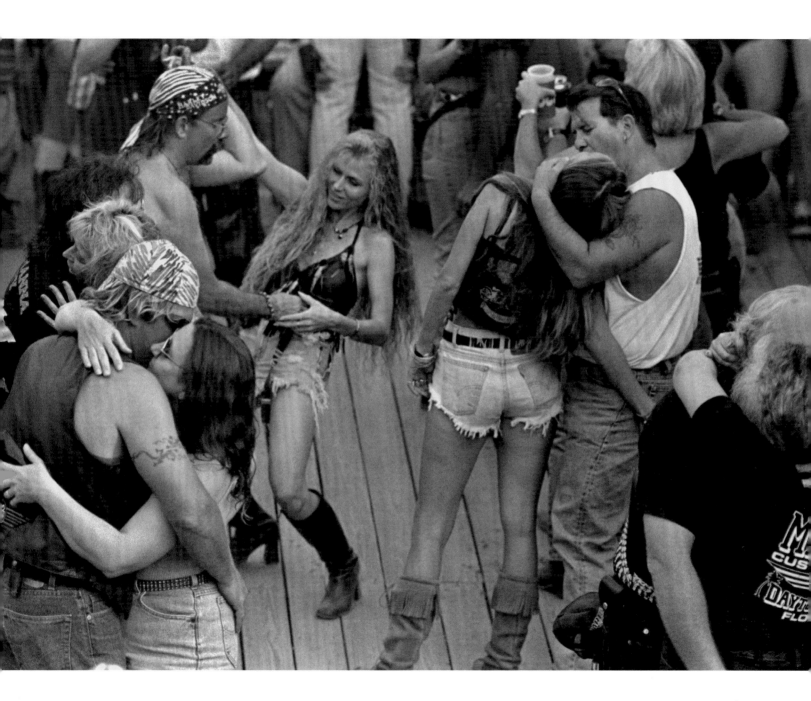

*Iron Horse Dance 1999* | 67

*Born to Be Wild 2000*

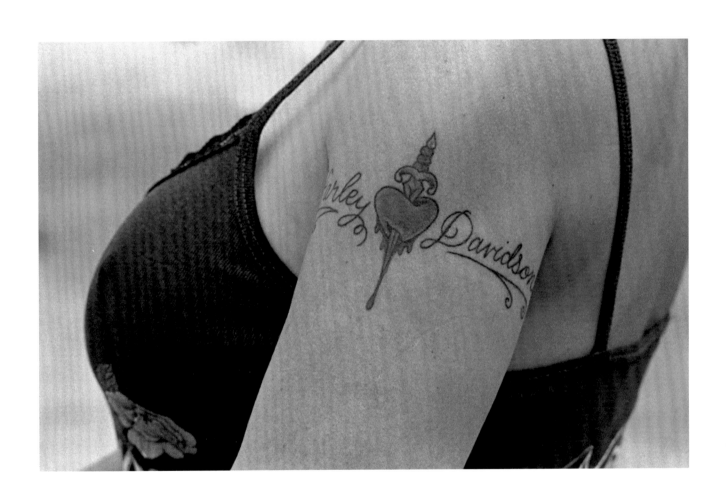

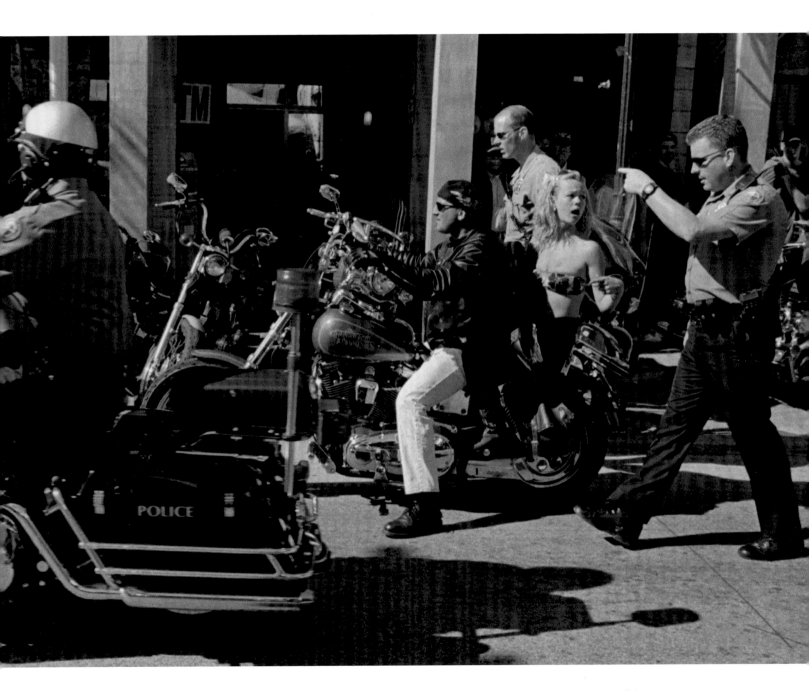

Left: *On Bass at the Cabbage Patch 2001*

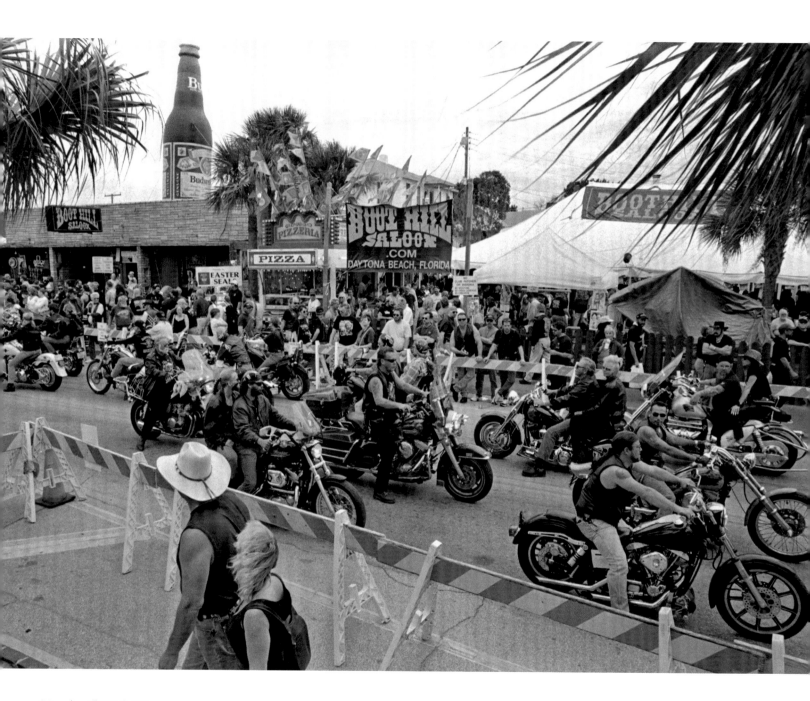

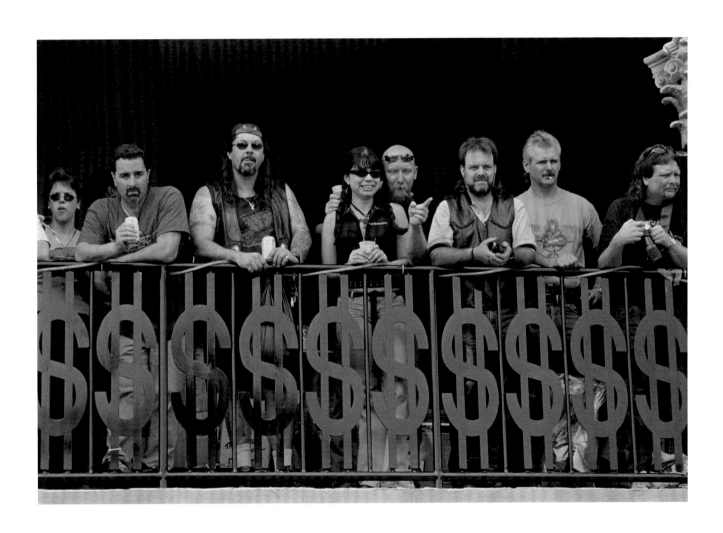

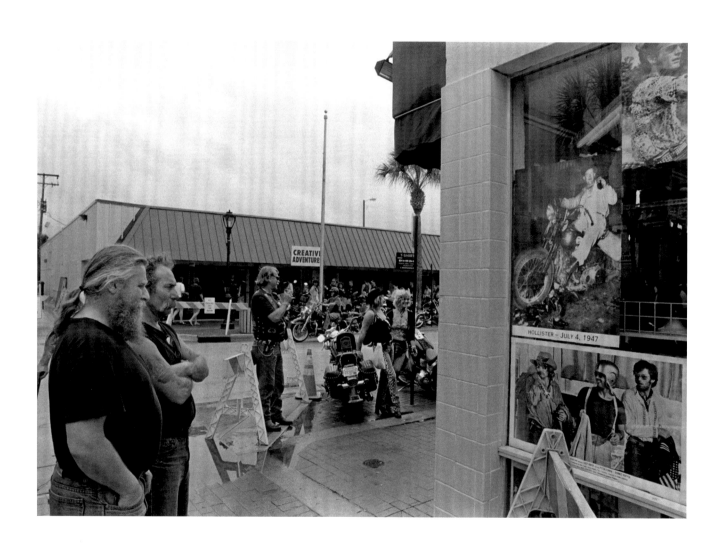

*In Observance of Biking Icons 2003*

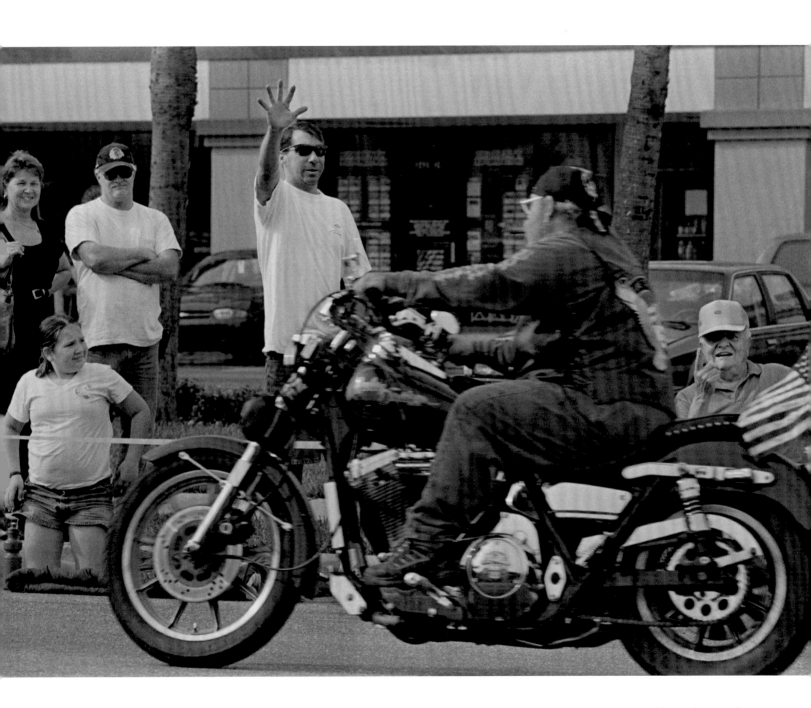

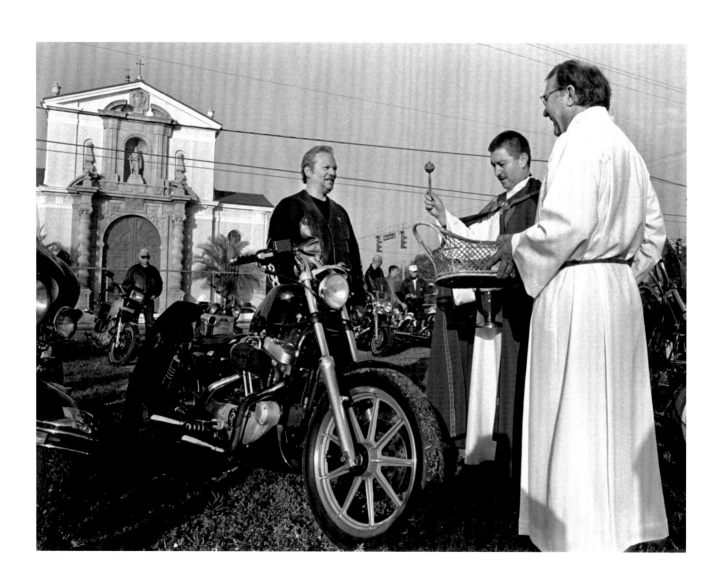

*Blessing of the Bikes 2001*

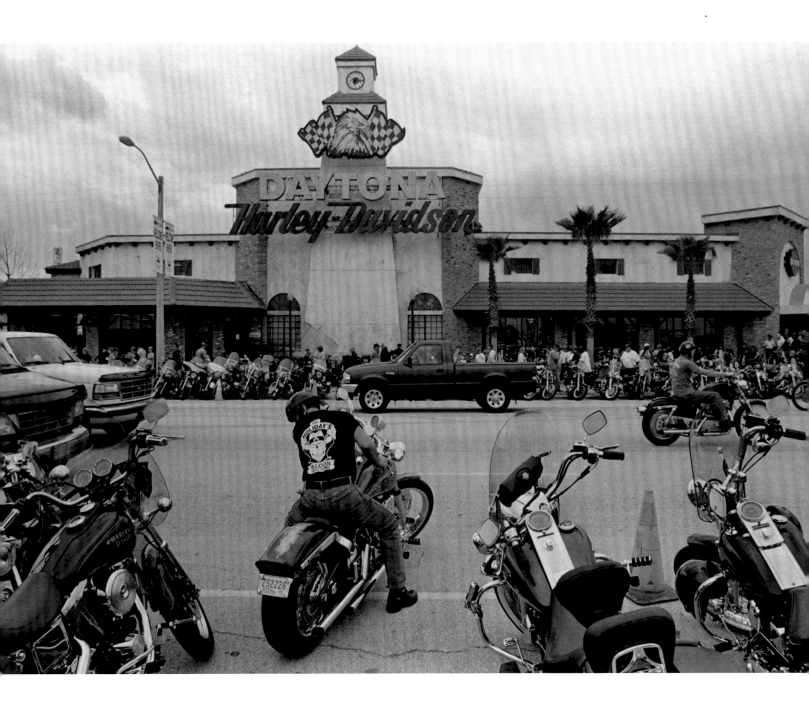

*Daytona Harley-Davidson 2000*

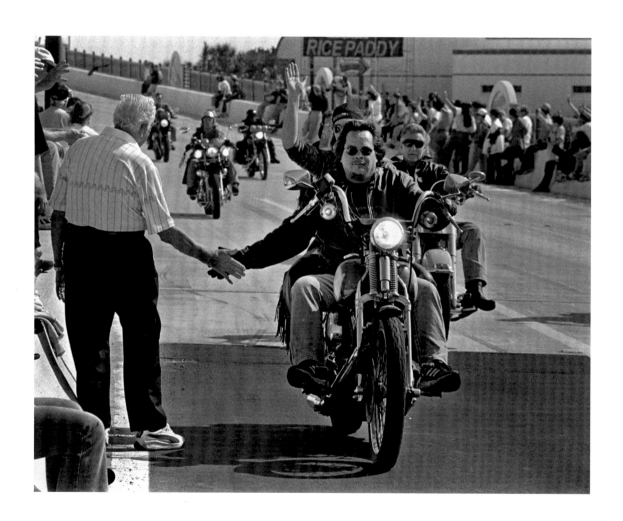

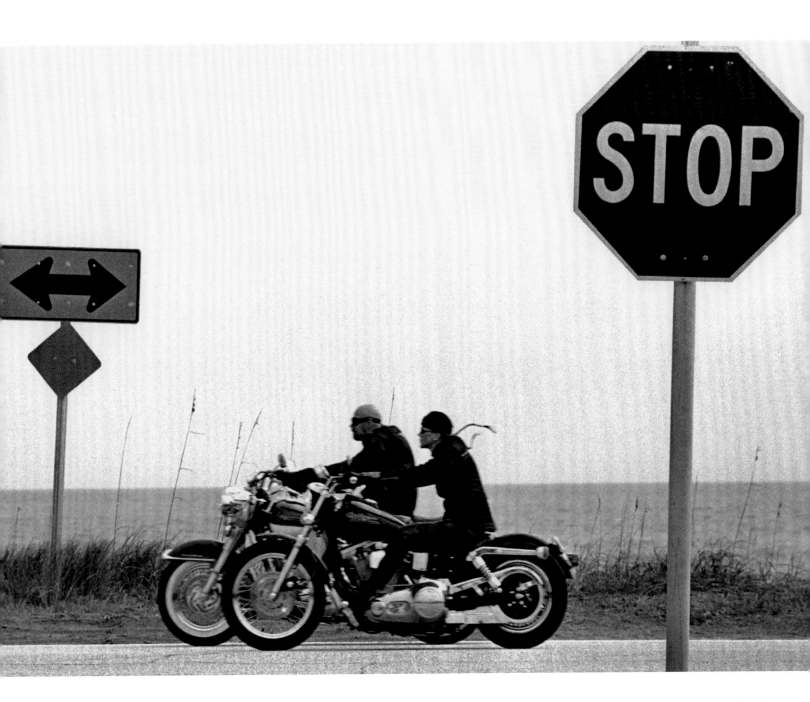

# BIKE WEEK

## at Daytona Beach

**Busy as the old St. Pete shop was Friday morning, it took a few hours to get the new front tire installed. The delay made me anxious to get on the road.**

I had crossed the state on Interstate 4 for Bike Week a few times before, and I didn't like the idea of finding myself anywhere around Orlando on a Friday nearing the evening rush. Discouraged by the outlook, I reminded myself that without snow or ice and with no rain in the forecast, traffic snarls were of relatively little concern. Still, I was disappointed to be getting started in the afternoon instead of the fresh midmorning.

I motor back across Tampa Bay, change to I-4 in downtown Tampa, and pass through heavy east-side construction on my way out the other side, all early enough to avoid heavy congestion. Riding east with the sun at my back, I recall my first ride to Daytona on this same route. Setting out much later in the day, I followed my brother and his girlfriend on his bike. A state trooper stopped us near the middle of the state and, for some reason, sent my brother down the road a mile to wait while he focused his ticket writing on me. I would have to return to the local county courthouse a month later for a brief appearance. Shortly after we resumed our ride, night fell as we neared Orlando. Following a gas stop there, we were left with a one-hour ride into Daytona. It was probably not much colder than 50 degrees, but in my inexperience I wore no thermals, only two thin jackets, and didn't even bring a pair of gloves. I recall that one hour of riding as more painful than the whole day I just spent getting through the snow and ice in North Carolina. It was the same stuff—cold wind, tightening leg muscles, numb hands and fingers—only made worse by having so little protection.

Such was my discomfort on that first ride to Bike Week that upon arrival at The Flame in Daytona, I enjoyed one of the most memorable hot dinners of burger and fries I've ever had. My body restored to proper functioning after dinner, we proceeded—with only a few attempts— to secure a room just a couple blocks off Main Street on Route A1A (Atlantic Avenue). Nowadays, arriving on the first Saturday night of Bike Week without a reservation is ill advised. For this year, I arranged months ago for a campsite the first half of the week and a small motel room on A1A, only a couple blocks from where we stayed that earlier year, for the rest of the week.

As anticipated, rush-hour traffic on I-4 in Orlando ranges from very heavy to standing still. At least sitting still provides a respite from navigating the hyped-up freeway traffic, although I remain alert for the possibility that the vehicles behind me might still be doing 65 miles per hour. My closest call on a motorcycle was in just such a situation—but I was the one closing fast.

It happened in my first year of riding. My friend Joe, who would join me in Daytona many years, and I were returning from a trip up the Blue Ridge Parkway. In heavy Friday-evening traffic, we were approaching the Atlanta beltway, riding at highway speed into the setting sun. We were in the same lane, staggered, with me in front. The lane to our right had just backed up to a stop for exiting to the beltway. In the dusky haze and glare, I was quite slow to realize that our own lane now also had backed up. Suddenly, there I was only car lengths from rear-ending a nearly stationary Volkswagen bug at more than 60 miles per hour. My right hand automatically went for the front brake, but I

knew that was useless before it left the throttle. Instead, having no time to check the lane to the left, I reflexively moved hard left and then back a little hard right, putting myself on the line between lanes. The VW flew by on the right, followed by the long row of cars in front of it. I gradually slowed and drifted left into that lane when I could check that it was clear, while keeping an eye on the row of sitting cars just off of my right knee. It turned out Joe was already over in that lane. We paused just ahead to squeeze into the beltway exit, as my heart rate cooled down. With a smile, Joe said he had been wondering when I was planning to change lanes.

Riding a motorcycle is fun, exciting, visceral, demanding, and dangerous. Rolling over the throttle and grabbing the handlebars to hold on, steering or leaning to navigate your way through curves, feeling the wind in your face . . . these are among the pleasures that come with riding. The unpleasant times usually result from bad weather and the disregard of other motorists. Riding requires considerably more concentration than driving a car, else you'll find yourself running off the road or run over by other motorists who will say they didn't see you.

Twelve motorcyclists were killed at Bike Week 2002, and four were killed the year before. The number of deaths is usually somewhere in between. Often while riding, I adopt a color code to help me stay focused, constantly reminding myself which color I'm currently in. Red means I've found myself in a dangerous position, and I need to take corrective action as soon as possible. Orange means I'm in a situation that doesn't necessarily present danger but makes me uncomfortable and ought to be improved. Yellow means I'm well positioned at the moment, but I must expect surprises and keep working to avoid orange. Especially on a motorcycle, it doesn't get any better than yellow.

I finally emerge from the northeast side of Orlando at sundown for the final half hour or so into the Daytona area. About fifteen miles short of Daytona, the bikes are swarming. I exit to head east toward Sopotnick's Cabbage Patch in Samsula. The Cabbage Patch is a small bar at a rural crossroads about fifteen miles southwest of central Daytona Beach and the heart of Bike Week. This week the little place swells into a carnival, filling the fields out back with live music, crafts, food and apparel concessions, motorcycle competitions, and coleslaw wrestling. Farther in the back are the tents and campers of those who don't get a lot of sleep at night. That's where I'm headed. I pull in near the back gate and am directed by flashlight down the row along the back wire fence to my small patch of field. There I pitched my tent in the dark, back close to the fence so that I might avoid being run over in the night.

The Cabbage Patch began its relationship with bikers in the late 1950s when Tomoka Farms Road going into Daytona was still dirt, said owner Ronnie Luznar Sr., whose family has owned the property since the 1920s. Luznar recalled how word initially spread about his family's place, which was a residence, a general store, and a dance hall before it became a bar. "They would say, 'You got to take that dirt road and just keep driving out until you get to that place that smells like cabbage,'" he said. "There's a little bar at the corner, and it's a good time there."

I finished erecting my tent and met the friendly couple next door, then wandered past the glowing campfires of my camp neighborhood, the illuminated food trailers with their greasy aromas, and toward the live music and boisterous activity up front near the bar. Gyro and beer can in hand, I watched the crowd grow near a makeshift stage as preparations were made for the evening's featured attraction. Tonight's contest, as every night with slight thematic variation, essentially involved women on stage, parading, dancing, and stripping. I took in some of the show, shot a game of pool at one of the two tables inside the smoky bar, explored the grounds, and returned to my tent.

My sleeping bag provided a nice warm refuge from the chilly night air but was of little help in blocking out the loud chatter among my neighbors and the constant rumble of passing motorcycles. I heard the guy next door return from up front with stories for his wife. He was a bit too forthcoming with details of the strip show, however. This prompted a few questions, followed by some irritated quizzing, leading to an increasingly heated argument, resulting in the dismantling of their campsite, and ending with their departure—this first night of Bike Week—for the one- or two-hour trip back home. I enjoyed an all too brief period of relative solitude before another, larger party set up camp next door and began a long night of revelry, drinking, drugging, and urinating.

Friday night slowly became Saturday morning, apparently there being as many early risers as there were late-nighters. Resisting the day as long as possible, I eventually mounted up and rode for town. It was nice traveling light now, without my load on the back. Twenty-some minutes later I reached downtown Daytona Beach on International Speedway Boulevard.

Crossing the Halifax River via the Main Street bridge, I arrived at the heart of Bike Week.

Police and other officials estimate the number of Bike Week visitors to be at least a half million annually, supporting the widely heard claim that Daytona is the world's largest motorcycle event.[1] Daytona Beach is unique among Florida's popular beaches for its connection with auto and motorcycle racing. The Daytona International Speedway is home in February to the Daytona 500, the year's major stock car race, as well as the Daytona 200, the preeminent motorcycle road race in the United States. The latter is held on the final Sunday of Bike Week. These two races, along with Spring Break and Black College Reunion, are the local tourist industry's main events.[2] Additionally, in the 1990s the popularity of Bike Week spawned a smaller, season-closing bike event called Biketoberfest.

Bike Week began in 1937 with the inaugural running of the Daytona 200. Daytona Beach had been the site of other motorcycle races, while the few previous runnings of the 200 were held in Savannah, Georgia, and Jacksonville, Florida.[3] Prior to the Speedway's completion in 1961, the 200 was held on the beach, half on the sand itself and half on a parallel street. A five-year hiatus (1942–46) due to World War II did not deter enthusiasts from coming anyway for unofficial celebrations each March. In the postwar years, along with the rise of the biker subculture, the unofficial revelry on the beach grew to be a larger part of Bike Week. The beach scene grew more distinct from the racing aspect of Bike Week with the completion of the Speedway and the race's move there.

The biker subculture peaked in the following two decades, and the character of Bike Week changed so that

bikers partying on the beach may not have cared, or even known, about the racing events going on across town. "There was a time back in the '60s and the '70s when Bike Week was a pretty hellish event," said Billy Stevens, former owner of the popular Iron Horse Saloon. "They had a lot of gang activity, they had a lot of unconstructive events going on." Local Chamber of Commerce president George Mirabal agreed. "[Main Street] was a dangerous place to be," he said, describing Bike Week up to the late 1980s. "It was really in disrepute."

Mark Robertson is the owner of Beach Photo on Main Street. His father, Alan Robertson, ran the shop before him and was one of Bike Week's most visible supporters during the 1980s. Mark Robertson described the scene on Main Street today as being very different from what he remembers of his earliest ventures on the street as a teenager in the 1970s. "Every single bike looked old, it looked dirty, it looked like somebody had lived on it . . . sleeping bags and all that kind of stuff," he said. "Now you got all these $25,000 bikes all in a row and you got all these businesspeople who happen to be wearing black shirts sitting on them." Robertson said the photo business, which thrives during Bike Week today, was very slow during Bike Week in those days. "Obviously a lot of people back then didn't want to take the chance of coming down here."

"It was the gang image. It was the one-percenters," said Ronnie Luznar Sr., owner of the Cabbage Patch. "A lot of businesses would close up. They didn't want to be bothered with them . . . scared to death of them." One business to have shut its doors during Bike Week sits near the west end of Main Street and is probably the most recognized of all Bike Week landmarks. Formerly known as the Kit Kat Club, the bar changed

hands in 1973, and new owner Dennis Maguire soon christened his place the Boot Hill Saloon. Maguire closed up during his first Bike Week "because he didn't know just what to expect and he despised the one-percenter element," according to longtime Bike Week supporter Bonnie Miller.

Maguire was "very, very anti-motorcycle gangs" said Mirabal, adding that Maguire was also the first one to establish "No Colors" rules prohibiting club members from wearing identifying insignia. Maguire, who died of cancer during Bike Week 2000, would go on to be recognized in Daytona Beach as one of several key players involved in making Bike Week the successful event it is regarded as today. "It's prophetic that Dennis passed away during Bike Week," said a subsequent statement from the local chamber. "Maguire was one of the true visionaries who enabled a complete turnaround of Bike Week from the perception of a disreputable event to one that is embraced not only by our visitors, but by our local residents."[4]

Arriving on Main Street Saturday morning, I came to the Boot Hill Saloon, on the right just a block or two after clearing the Main Street bridge. I continued down the street, basically walking the bike along in the bumper-to-bumper—or wheel-to-wheel—traffic. Main Street is indeed the main street at Bike Week, running about ten small blocks from the bridge to the Atlantic Ocean. Parked motorcycles line both sides of the street from the river to the ocean, sitting handlebar to handlebar with their back wheels at the curb. Behind the bikes, pedestrians crowd the sidewalks and slowly make their way up and down the street, browsing among the shops and bars and watching the parade of bikes crawling past. In the 1990s, a number of new bars opened along the

street, some with sizable outdoor patios and bandstands, multiple service counters, and more contemporary amenities. Some even have carpeting.

I prefer parking on Main Street to avoid the risk of theft on the quieter side streets. During Bike Week 2001, fifty motorcycles were reported stolen throughout the Daytona area. Further on up the street I spotted an opening, secured the bike there, and walked down to the pier that extends from Main Street into the ocean. Below me, cars and motorcycles passed under the pier as they idled up and down the beach. Daytona Beach has long been famous for allowing motor vehicles on its beaches. For many riders, some coming from colder latitudes, the beach has traditionally served as the ultimate destination. It also was the only place where riders could go helmet-free. But in 2000 Florida repealed its thirty-year-old mandatory helmet law, so the beach no longer held that particular attraction. Anyway, in order to attract upscale beachfront development, by then the city had prohibited traffic on this one-mile central strip of beach.

I passed back by my bike and continued up Main Street on foot, browsing in some shops, looking over the thousands of motorcycles, and taking in the spectacle. This is a see-and-be-seen scene, with many showing off and many more enjoying the show. Despite the fact that the vast majority of motorcycles are of a single brand, they exhibit every imaginable variation, from paint schemes to mechanical customizing both minor and major. There were new bikes, old bikes, and antique bikes; two-wheeled bikes, three-wheeled trikes, bikes with sidecars, and bikes set up to accommodate riders who use wheelchairs; small bikes, large bikes, loud and louder bikes, and bikes with 8-cylinder engines mounted in them. One functioning bike looked like it was made entirely of wicker.

It is not only the motorcycles that are on display. Most everyone is dressed in some combination of T-shirt, denim, and leather. Some are neatly and painstakingly dressed up in biker "costume," some look like they could use a change of clothes, and most fall somewhere in between. A few more exhibitionistic women wear barely a bikini. Scantily attired women tend to draw a crowd, men with cameras pleading for a show of even more skin. While the police are less tolerant in recent years toward displays of nudity, occasional flashes still occur, even if they might lead to a reprimand or citation from one of the many officers stationed along the street.

Nearing the west end of Main Street, I approached the Boot Hill Saloon, directly opposite Pinewood Cemetery. "Order a drink and have a seat. You're better off here than across the street," the Boot Hill has long advised. I went inside the dusky saloon and squeezed my way up to the long bar for a cold bottle of beer. A band, led by a bawdy front man, blasted classic rock numbers and some rolling blues tunes. At the top of the hour a bell rang long and loud, while bartenders chucked T-shirts, bandanas, panties, and other Boot Hill merchandise out across a throng of waving arms and hands. Keeping up with the explosive growth of Bike Week, in recent years the Boot Hill has been erecting a large tent over an outdoor stage and service counter, more than doubling its space.

T-shirt merchandising serves as another measure of the increasing popularity of Bike Week. In the late

1980s, the Boot Hill sold its T-shirts from a counter in the back of one of the bar's three rooms. Increased demand now has the bar devoting a whole room strictly to merchandise sales and setting up a large outdoor booth as well. At least one competitor recently staked a claim for greater biker authenticity by advertising, "We sell beer, not T-shirts." But the sentiment being tapped is a flat one, overwhelmed by the reality of today's Bike Week and the fact that sales of T-shirts and other merchandise are routine for most all of the area biker bars. "The majority of our revenue comes from the sale of T-shirts and other stuff with the Boot Hill logo on it," said co-owner Gary Gehris. Gehris, who acquired the Boot Hill from Maguire, died in 2002, leaving the Boot Hill to his wife and co-owner, Karin Gehris.

Settling in to watch the band and some feverish dancing, I recalled a night in that room from 1988 when I watched a few women at the front window unfurl a poster-size, iconic biker image: long hair flowing behind him, a biker throttles his chopper across a western panorama, with the ghost of a Wild West horseman keeping pace at his side. A crowd circled around in appreciation of the image and its portrayal of certain celebrated values in the biker subculture: the freedom of the open road and the individualist spirit often associated with the Wild West. Such cohesion of biker spirit is no longer likely to be found in the Boot Hill Saloon and perhaps is difficult to find anywhere at Bike Week. The event today attracts too diverse a crowd for that. There surely is plenty of fun to be found at the Boot Hill these days, but, as elsewhere at Bike Week, it all comes off as a little more tourist attraction and a little less biker mecca.

The popularization of Bike Week at Daytona Beach began during the 1980s. As I described earlier, the Harley-Davidson Motor Company began to experience a renewed interest in its brand during the same period. Underlying both the changes at Daytona and those at Harley-Davidson were demographic shifts centered upon the aging of the baby-boom generation. We saw how these broader trends played out for Harley-Davidson. Similarly, Daytona Beach went through years of adjustments as it adapted to underlying changes in the biker subculture.

By 1985, long-simmering tensions between the citizens of Daytona Beach and the invading bikers each March were rising to a boil. The city's resolve to improve the blighted Main Street area and make it "free of the scum," according to a city administrator, was demonstrated by various new plans for redevelopment.[5] A 1986 planning study to explore new uses of buildings and land concluded that the Main Street area should be transformed into a large entertainment district. The revamped area would feature shopping and dining establishments, similar to the downtown redevelopment projects then springing up in other Florida cities, such as Jacksonville and Tampa, and elsewhere around the country.

Specific recommendations in the study included extending the boardwalk south of Main Street and, at the other end of Main Street, developing the gateway area along the Halifax River. In 1985 and 1986, the Daytona Beach city commission also established new redevelopment zoning districts along Main Street and the boardwalk, a code enforcement board, and an ordinance mandating repair and other improvements to building exteriors.[6]

Just a block north of Main Street, the Ocean Center Arena opened its doors in 1985. Directly across Route A1A from the arena, a seventeen-story Marriott hotel sprouted in 1987. Known today as the Adam's Mark, the block-long oceanfront hotel complex was made possible with the city's purchase of nine properties—a few with the help of eminent domain suits. The city hoped the arena and hotel combination would attract conventions and other business, especially during the off-season. More generally, the new facilities together with improvements along Main Street would be a start toward replacing the negative biker element with a new and improved image for Daytona Beach.[7] It probably was not predicted that the complex, in addition to being a significant component in the area's makeover, would in a few years be rolling out a warm welcome to bikers and hosting the Harley-Davidson Expo.

In March 1985, prompted by increasing hostility toward Bike Week from city officials, a group of the event's supporters met at the now-defunct Kay's Coach House on Main Street. Prominent among the supporters were the Boot Hill Saloon's Dennis Maguire and Alan Robertson, owner of Beach Photo, according to Bonnie Miller, who also attended. She said progress was slow at first, as the fledgling group did not receive the support of city officials and the police. "We were unable to shake Chief [of Police Charles] Willetts's contention that all bikers were trouble," Miller said. Mark Robertson remembered city officials visiting his father at the photo shop and telling him that Bike Week was finished. "This is the last Bike Week, this is it," he recalled. "We're not going to put up with this anymore."

Of course, the city could not stop bikers from coming; the city hadn't invited them to begin with. The question became whether city officials would make Daytona Beach so unappealing to bikers that they might no longer want to come, at least in significant numbers. One focal point of concern for the self-appointed Bike Week defenders was a set of rezoning and streetscaping proposals for Main Street that included a ban on all parking. "Bikers come here to cruise Main Street, park on Main Street and go have a beer in a bar on Main Street," said Maguire. "Get rid of that and you get rid of Bike Week." The city's director of planning and redevelopment, Gerry Langston, admitted that the rezoning would "inhibit" Bike Week as it then existed. But he also acknowledged the silver lining in the dark cloud looming over Bike Week. "The motorcyclists are such a strong force and bring so much money into the area, they'll have to be accommodated in some way," he said.[8]

During Bike Week 1987, George Mirabal was just arriving in Daytona Beach to assume leadership of the Chamber of Commerce. Coming from out of state and having never heard of Bike Week, Mirabal said he looked at the newspaper's coverage of it each day and asked himself, "Where am I moving to? What am I doing?" That week's Monday paper, for example, described the start of Bike Week in foreboding terms compared to the cheery spirit of its coverage in recent years. "For police, coping with the invasion of bikers is a trying time at best because the potential for trouble is always there," the front-page article said.[9]

Nevertheless, upon learning that the 150,000 people attending Bike Week at that time left $90 million in Daytona Beach, Mirabal soon knew what he would be doing. "We set a goal to increase the quantity and quality of the bikers and to turn it into a festival," he said.

"What we wanted to do was turn this into a motorcycle event where everybody was welcome with the exception of what some people call 'one percenters,' but really they were 10 percenters, maybe 15 percenters."

And so the next Bike Week, 1988, was the first year in which the familiar "Daytona Beach Welcomes Bikers" banners were hung over Main Street. Long-pending streetscaping plans were adjusted to eliminate car parking but permit motorcycle parking on Main Street. The Main Street makeover—including new streetlights and traffic signals, landscaping, and a more decorative repaving—began soon after Bike Week that year and was completed in time for the 1989 event. A key element of the renovation was to broaden the sidewalks and install low curbs so that motorcycles could park by backing up onto the sidewalk.

In making these changes, the city enlisted the support of Bike Week's self-appointed defenders, who would become officially recognized as the Bike Week Festival Task Force. This union signaled a key shift toward cooperation by uniting formerly disparate interests—Bike Week's supporters, on the one hand, and, on the other, the city representatives who had long held a negative view of the event. Alan Robertson led the task force for a decade, prior to his death in 1996. "Alan was the first to say we should transform Bike Week into a festival," Maguire subsequently said. The *Daytona Beach News-Journal* editorialized that Robertson "was a key force in transforming Daytona Beach's Bike Week activities on Main Street from dreaded chaos into an organized festival."[10]

Another significant force in Bike Week's transformation was Paul Crow, who replaced Charles Willetts as police chief upon the latter's resignation in 1988. With Crow's arrival, "all the hassling that was being done by the police department changed," said Mirabal. Karl "Big Daddy Rat" Smith, an early Bike Week supporter and organizer of the annual Rat's Hole Custom Chopper Show, asked Crow to draft a sort of peace offering to bikers. Crow agreed to the request and wrote a letter promising a more welcome atmosphere—provided that bikers behave. The letter was distributed to publications worldwide, and although many bikers were doubtful, Crow more than lived up to his word, Smith said. "Crow did a hell of a job turning this around," he commented. "Crow was the one that created all the smoothness. He created a whole different atmosphere." Smith died of a heart attack at age seventy-four during Bike Week 2002.

Over at the Iron Horse Saloon, owner Billy Stevens agreed that Crow, a motorcycle enthusiast himself, was a fortunate hire. "They decided to try and develop Bike Week and nurture it instead of push it out of town," he said. "[Crow] was much more receptive to motorcycle people; he was much more receptive to working with the business owners." The Boot Hill Saloon's Gary Gehris offered a similar view. "There was a bunch of police who didn't like bikers, and the city finally realized they made more revenue from bikers than any other event in town," he said. "Their policies had been really stupid, and they weren't going to try to get rid of the Boot Hill Saloon any longer."

Despite the city's new personnel and their more favorable outlook toward Bike Week, the event still had a negative image among much of the public—prospective visitors as well as locals. Reporting on the

findings of a tourism study in 1987, the *Daytona Beach News-Journal* wrote that the city had a "perceived sleazy or honky-tonk image" in the eyes of potential visitors. Focus-group sessions in several out-of-state cities discovered unfavorable descriptions of Daytona Beach: "not wholesome," "rowdiness," "not for families," "like a drag strip," "unsafe," "overcrowded," and, simply, "motorcycles."[11]

In an editorial the next day, the *News-Journal* reluctantly noted that in 1979 *Penthouse* magazine had branded Daytona Beach the "sleaze summit of the United States." But the paper defended its city on the basis of its progressing redevelopment efforts.[12] Indeed, Miller said that surveys by the city indicated that at least local opinion on Bike Week improved considerably in only a few years.

Through the 1990s, the restyled event settled into relative normalcy, albeit an expanding one. More people—bikers and nonbikers alike—came to Bike Week as the years passed and as motorcycling enjoyed a booming popularity. "We went up to 500,000 [visitors], $250–260 million," said Mirabal. According to Miller, "It was apparent even to its detractors—who were now far fewer—that Bike Week had arrived. Daytona Beach's Bike Week currently runs pretty much like a well-oiled machine, after all these years of strife and work and effort."

I left the Boot Hill Saloon to find my bike among the hundreds of other bikes along Main Street and headed back across the Halifax River for the mainland. The Main Street bridge deposited me on Beach Street, which runs parallel to the river on the north edge of downtown Daytona Beach. In the 1990s, expanding Bike Week festivities jumped the river from the Main Street area and began flourishing along Beach Street.

Anchoring this new hive of activity since its 1994 opening is the Daytona Harley-Davidson dealership. The franchise owns another new shop down at the "south end," in New Smyrna Beach, as well as a small merchandise store on Main Street. Daytona Beach's previous Harley dealer operated out of a smaller store several blocks away. Owner Joe Robison said he sold his thirty-one-year-old franchise to the new dealer due to his advancing age and given the fact that he was under increasing pressure from Harley-Davidson to upgrade his store. "The market was so good anymore for motorcycles that they wanted a new facility and all, and I didn't want to get into that type of operation," Robison commented. "I wasn't cut out to go along with the times." Instead, he kept his shop as it was, minus the franchise, and now enjoys a slower pace. "Every day there's people coming in from all the way back through the years," he said.

In addition to the growth along Beach Street, Bike Week activities have proliferated around certain locations dispersed throughout the whole of Volusia County and beyond. To the south, Bike Week action extends about fifteen miles to New Smyrna Beach. Pub 44 sits next door to the Harley dealership in New Smyrna and has grown from a modest lounge in the 1980s into a large indoor-outdoor biker oasis—an oasis of biker commotion amid the surrounding suburban composure. My campsite at the Cabbage Patch was about ten miles west of Pub 44; ten miles farther west is the Volusia County Fairgrounds, site of this year's four-day swap meet.

The Daytona International Speedway, site of racing events and extensive vendor displays, is about five miles west of Main Street. Between the Speedway and

Main Street is Bethune-Cookman College, where a five-block stretch of Dr. Mary McLeod Bethune Boulevard resembles Main Street but draws a predominantly black crowd. About eight miles north of Main Street, the Iron Horse Saloon is the headline attraction among a series of mostly new biker-themed establishments along U.S. 1 in Ormond Beach. Farther north in neighboring Flagler County is Bulow Resort, a full-service campground featuring bands, contests, and parties, leaving many guests with little need or desire to make the twenty-mile trip to Main Street.

The next day, I rode up to the Iron Horse Saloon. Traffic slowed to a stop on the four-lane, divided U.S. 1 as I approached the half-mile stretch of biker-related congestion that the Iron Horse created. First bar on the left, the Iron Horse is fronted by a small, run-down building with rows of motorcycles parked in front of it right up to the edge of the highway. Motorcycle-related vendors have set up along the left side of the road past the Iron Horse; across the street are other biker locales, all the way down to Smiley's Tap, a small bar predating the Iron Horse. Police periodically held traffic so pedestrians could switch sides across the busy highway.

I turned into the Iron Horse and followed the gestured instructions of orange-vested parking coordinators, one after another, to the dusty, two-acre back lot. Dropping my kickstand on a crushed beer can, I found myself surrounded by hundreds of bikes, outdoor bars, food booths, a bandstand, and a sprawling elevated boardwalk. With an atmosphere similar to the Cabbage Patch but a layout more compacted, the Iron Horse is a noisy carnival of biker activity. Barkers pitched motorcycle stunt shows and game booths; motorcycles' engines screamed while their tires turned to smoke in the burnout pit; a band played classic rock, blues, and country hits; some people danced; and hundreds of others wandered about.

Before it became the Iron Horse Saloon, the little building in front was a church and then a small restaurant called The Koffee Kup. The bar moved here after being kicked out of the Main Street area in 1987, according to former co-owner Billy Stevens. Once the city of Daytona Beach started making changes on Main Street, he said, "the very first thing they wanted to do was to get rid of all that scumbag, transient, biker bar business." Stevens said the city's new building and land restrictions resulted in the original Iron Horse being condemned and torn down. "The city was doing its best to get Billy's building, tear it down, and build a parking lot," said Bike Week supporter Bonnie Miller. They "would have dearly loved to see the Iron Horse disappear into the sunset—and would have particularly adored seeing the Boot Hill Saloon just sort of fall off the face of the earth," Miller said of Bike Week's early opponents.

While the Boot Hill survived and prospered on Main Street, the Iron Horse had trouble finding a new location before finally settling on its current spot. Even then, the bar's future was uncertain, Stevens said, due to neighbors' complaints and given concerns about whether Bike Week crowds would come up from Main Street. "We were not received very well by the neighbors," Stevens noted. "[They] signed a petition against us the first year . . . did not want our kind of people up here . . . did not want them dirty old bikers up here in Ormond Beach."

Nevertheless, the new Iron Horse proved so popular that it led the way in establishing Ormond Beach as a major biker destination. "As you can see by both sides

of U.S. 1 as far as you can see in both directions, we are now very liked in the community," Stevens said. A prominent sign in the middle of the Iron Horse complex reads "R.I.P. Main Street Daytona. They told us to leave, even sent us a letter; so we moved ol' Iron Horse, and the best just got better."

The same changes that brought tremendous growth to Bike Week also brought dissatisfaction among some longtime attendees who bemoaned the event's new popularity. Bike Week not only had become organized and mainstream; these qualities meant it also was losing some of the indiscriminate hedonism that for many was its appeal in the first place. "There are a few old diehards that still want to see everybody take their clothes off and get stupid, and we all like to see a little of that from time to time, but Bike Week is a family sport," said Stevens. Citing several children's events now offered at the Iron Horse Saloon, he added, "Everyone should be able to enjoy it."

Observing the Bike Week of recent years, it does appear that everyone is enjoying it, or at least that everyone is invited to enjoy it. Since the late 1980s, Bike Week has become a more welcoming event, reflecting greater diversity among Harley-Davidson riders and motorcyclists in general. Previously, Bike Week was not welcome in Daytona Beach, and nobody else was much interested in the event and its outsider—and sometimes intimidating—participants. Today, the outsiders have moved inside, the city of Daytona Beach is proud of its annual Bike Week, and the event draws national and international attention. In 2000, even Ormond Beach's mayor was riding his Harley-Davidson at Bike Week. Also that year, the television program *Good Morning America*, as good a symbol of mainstream America as any, broadcast a live segment on Bike Week's opening day to its nationwide audience.[13] And inside the dark, loud, and seemingly chaotic Boot Hill Saloon during a recent Bike Week, a television up in the corner silently flickered on the Weather Channel. There among the featured weather reports for established festivals and other special events around the country, the forecast was for sunny skies at Bike Week in Daytona Beach, Florida.

Whatever the changes at Bike Week, the event remains in one sense simply a fun party. Just as in decades past, younger newcomers and seasoned regulars are attracted to the free-spirited environment that Bike Week offers. Here they find the opportunity to cut loose from the restrictive binds of ordinary life and experiment with new and different behavior. The hundreds of thousands of motorcyclists who keep coming must be enjoying themselves, or else they would not keep coming. Stevens nicely sums it up: "With each generation of people comes along a change, and what used to be when I was young is no longer now. Some people like to see the change, and some people just like to sit around and harp on the good old days. Well, there are good old days, and good old days are fond to remember. But boy, these days are great. We have a great time with the people that come today. There are a lot more people wearing new leathers and buying new Harley-Davidsons. But they still enjoy the same camaraderie, they still enjoy riding with the wind in their face and blowing through their hair, they still like and do the same things that we all did when we came here to party and weren't businesspeople; only it's a different generation."

The story does not end there, however. Daytona Beach's plans for redevelopment in the Main Street

area continued to evolve. The Adam's Mark recently saw an expansion, and to its north rose the nineteen-story Ocean Walk condominium hotel.[14] Between the two hotels, Beach Village has appeared, featuring a multiscreen, stadium-seating theater complex and several restaurants. The Chamber of Commerce's George Mirabal said other proposals include a completely rebuilt boardwalk that extends south of Main Street and redevelopment of the oceanfront property south of Main Street to include a high-rise, similar to what has occurred to the north since the mid-1980s. By 2001, redevelopment on Main Street had finally reached the Halifax River with construction of The Wreck, a bar on the river's edge.

Since Bike Week 2001, it has been evident that Bike Week's image also is subject to continued evolution. After years of official as well as public opinion focusing almost entirely on Bike Week's successful turnaround since the 1980s and its benefits for the area, now there was growing antipathy for Bike Week and other special events. Local citizens were growing more critical of the motorcycle noise and the congestion-related problems of having so many visitors invade their city. The balance of opinion on the city commission also grew increasingly critical of Bike Week. "What business wants to move their family into Daytona Beach with the image that we project?" asked Commissioner Darlene Yordon.[15] Bike Week's detractors, recognizing a nearly immutable link between Daytona Beach and its special events, only advocated scaling them back and taking more control to limit their excesses.

Economic studies were conducted to determine how the city fares during Bike Week and other events, but the results only prompted debates about the numbers and how to interpret them. With a lot of support from area merchants, so far actual changes to Bike Week have been minimal. "Bikers couldn't be more welcomed," said Mayor Bud Asher. "We're just asking all people who visit here during special events to have a good time but to abide by our laws and exhibit the same conduct of our citizens and to respect our citizens' right to enjoy their quality of life as well."[16]

Meanwhile, the Boot Hill Saloon took part in a billboard advertising campaign encouraging motorcyclists to quiet their machines. The national Motorcycle Safety Foundation spread its "Take It Easy" message of safety throughout the area on billboards, pins, posters, and coasters. Daytona Harley-Davidson announced, just prior to Bike Week 2003, plans to build a new dealership north of Ormond Beach and stage its Bike Week events there to avoid rising special event fees in Daytona Beach. At the same time, Orlando Harley-Davidson is promoting its own Bike Week, hoping to attract people who are tired of the room rates, crowds, and growing backlash in Daytona.[17] While there has been talk about Orlando stealing Bike Week, its rise may simply represent yet a further expansion of Bike Week.

After growing in respectability in the minds of so many in recent years, it may be that Bike Week has reached another turning point where some of its gains in popularity and acceptance are reversed. Whatever the future holds, the past twenty years demonstrate what seems obvious with hindsight but often is overlooked in short-term considerations: the atmosphere of an event, and even the image of a long-standing subculture, can change dramatically.

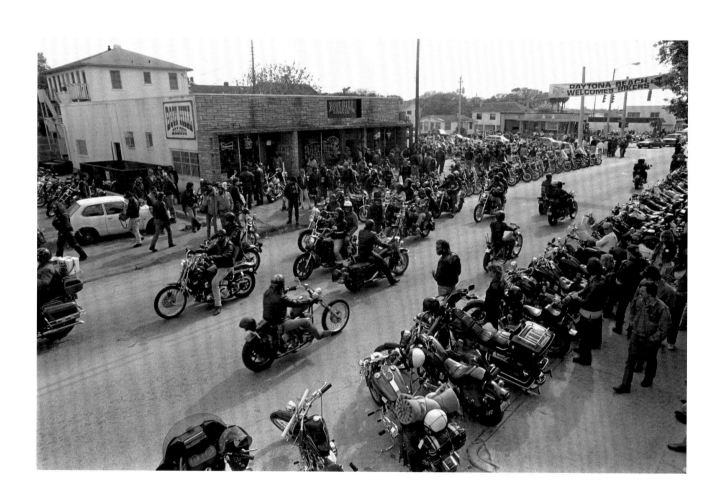

*Boot Hill Saloon 1989*

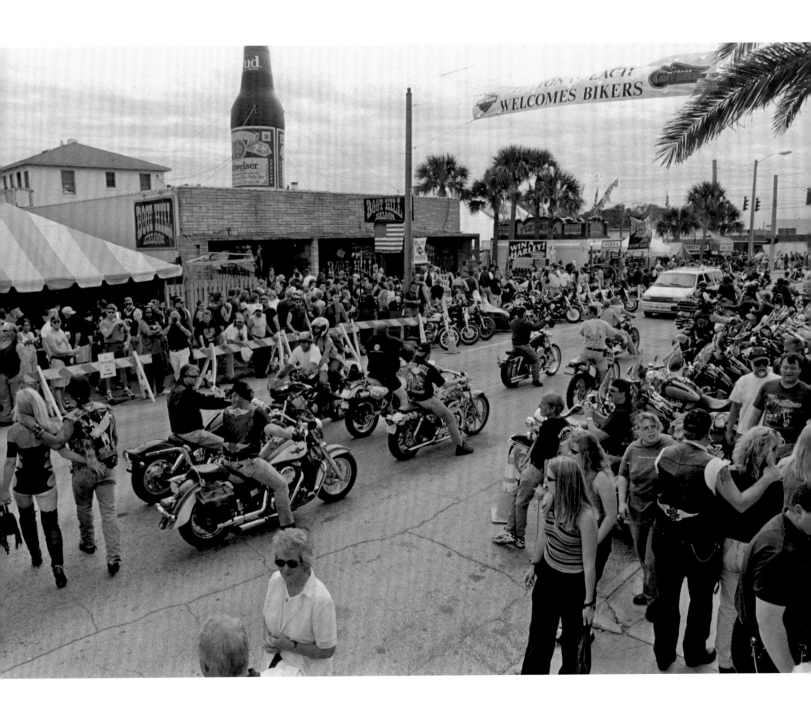

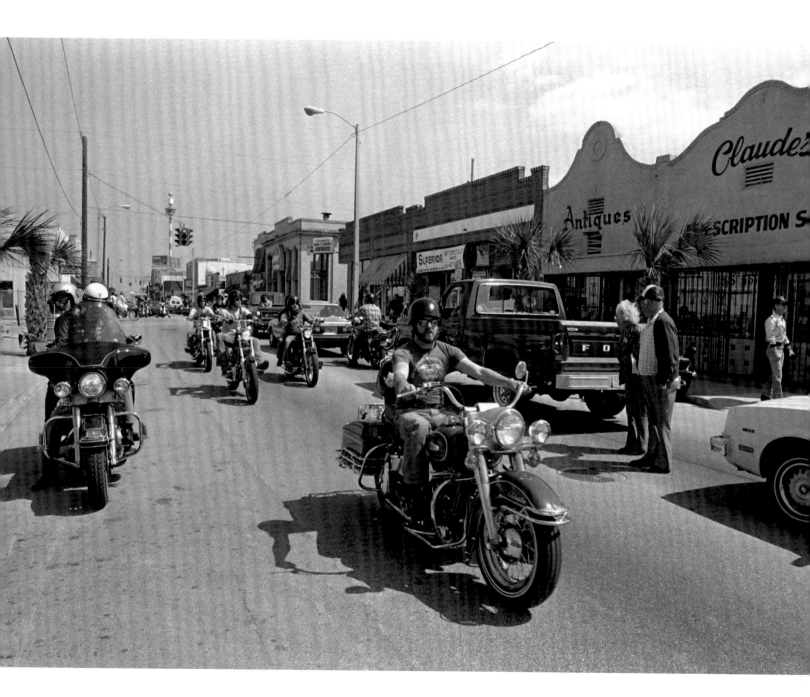

*Main at Noble 1985*

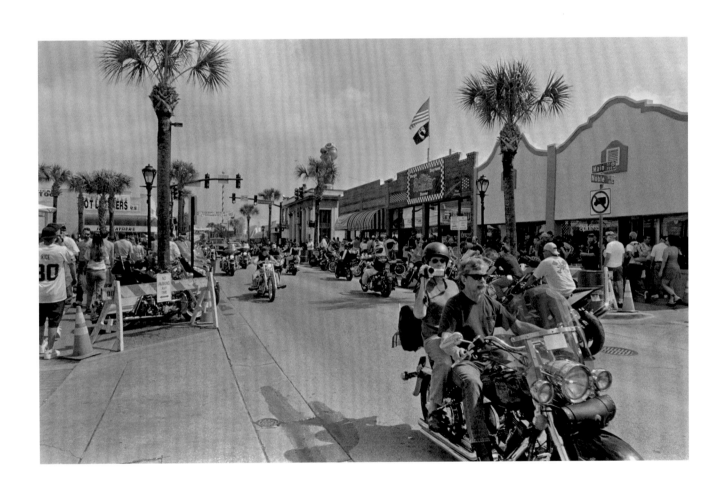

*Main at Noble 2003* | **97**

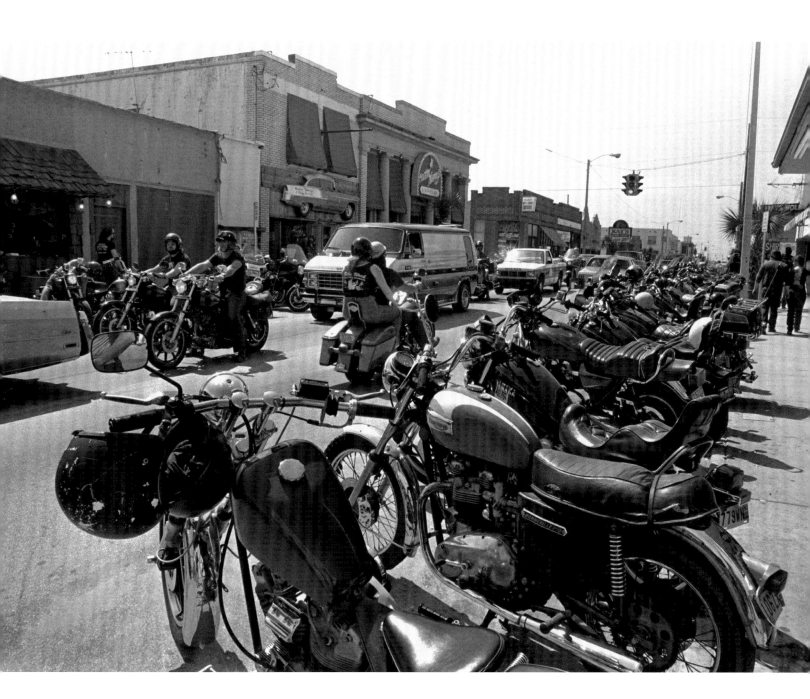

*Main at Fern 1985*

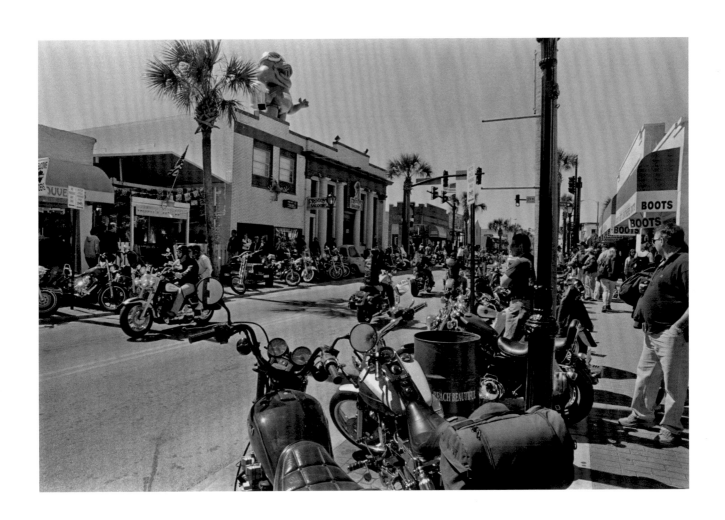

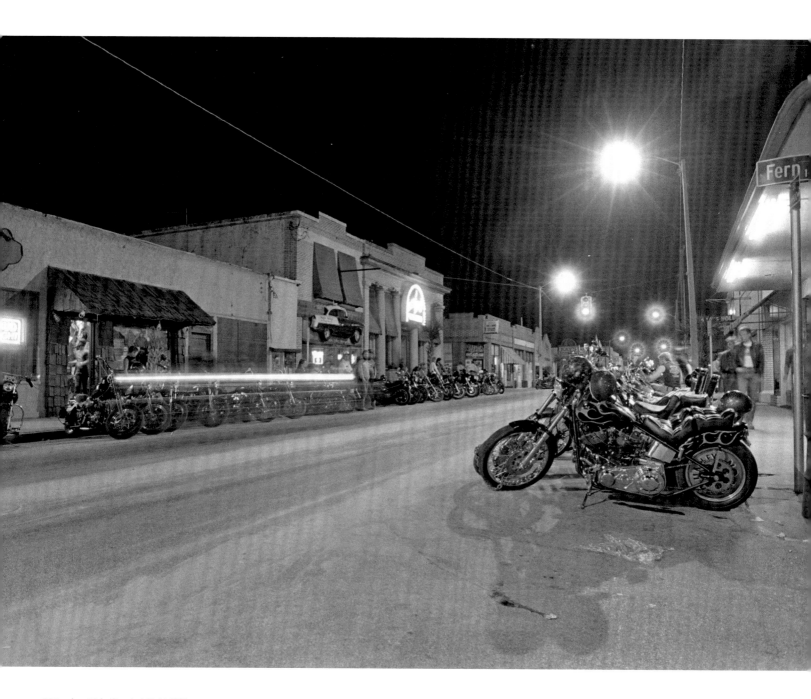

*Main Street at Night 1985*

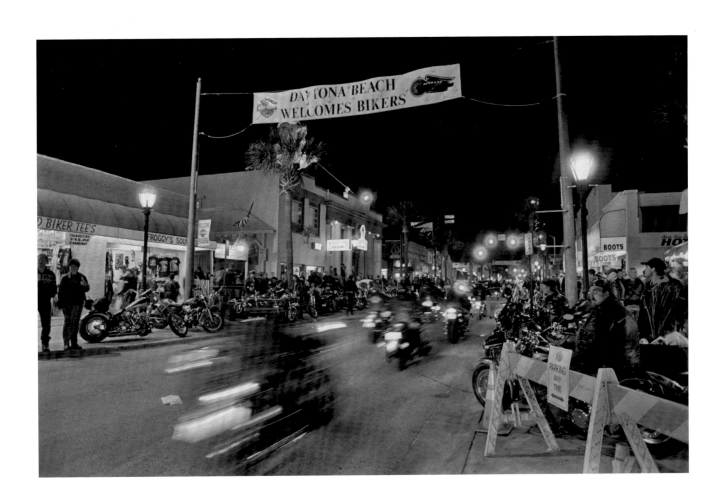

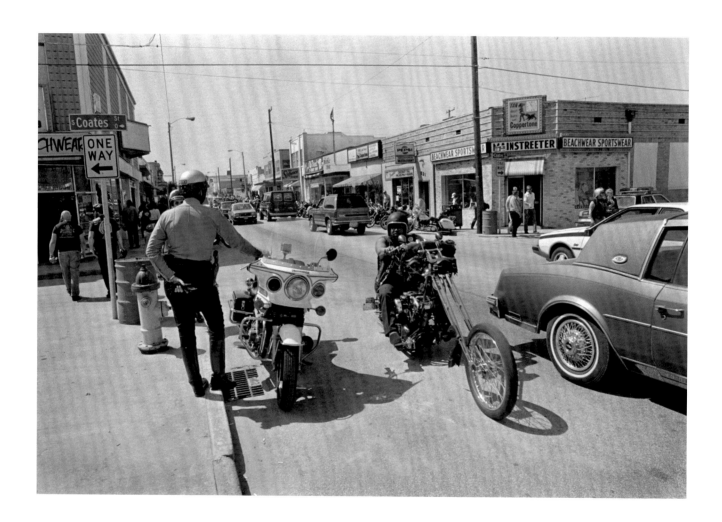

*Main at Coates 1985*

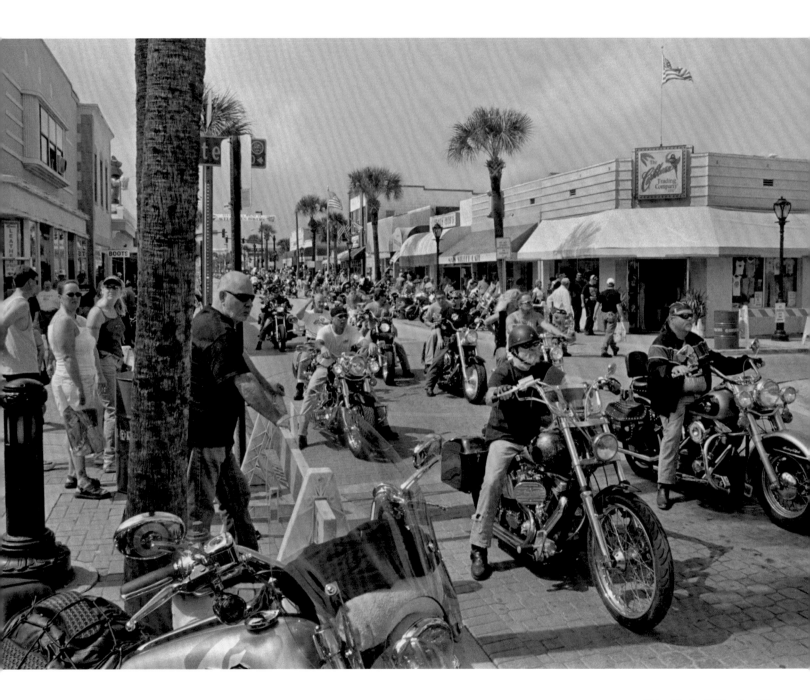

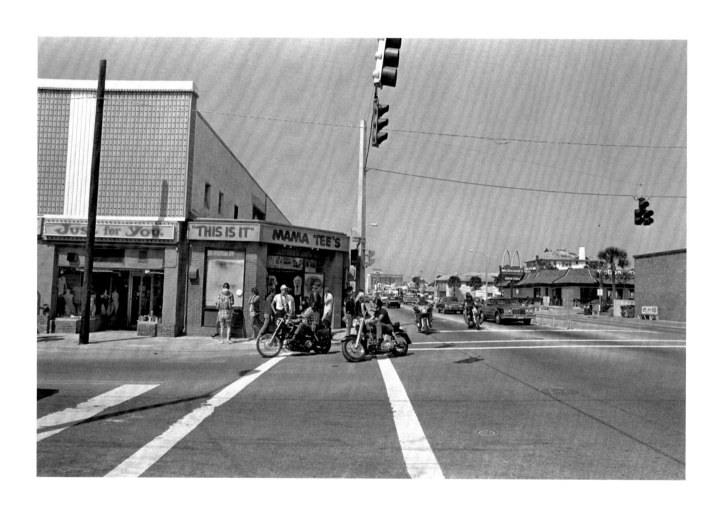

*A1A from Main 1985*

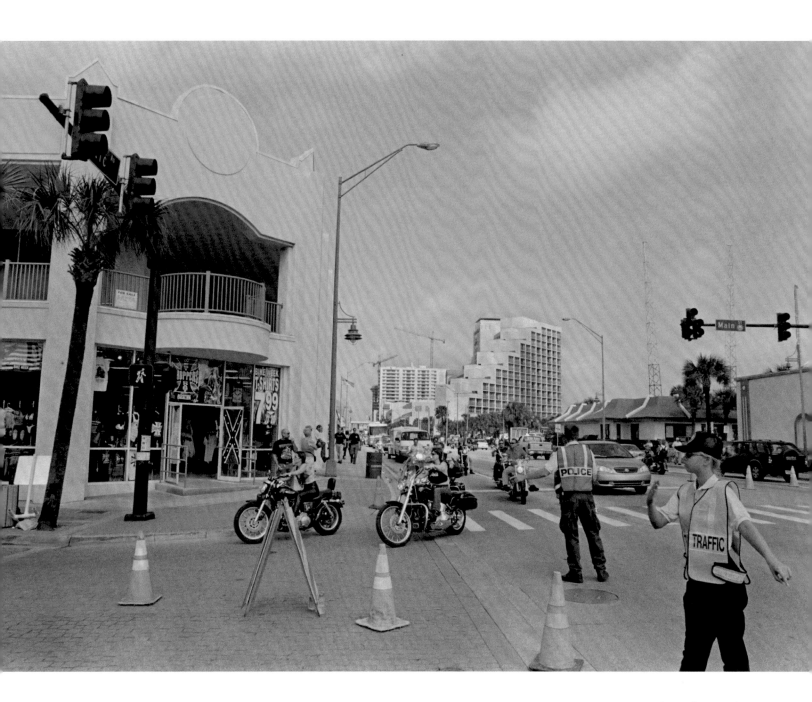

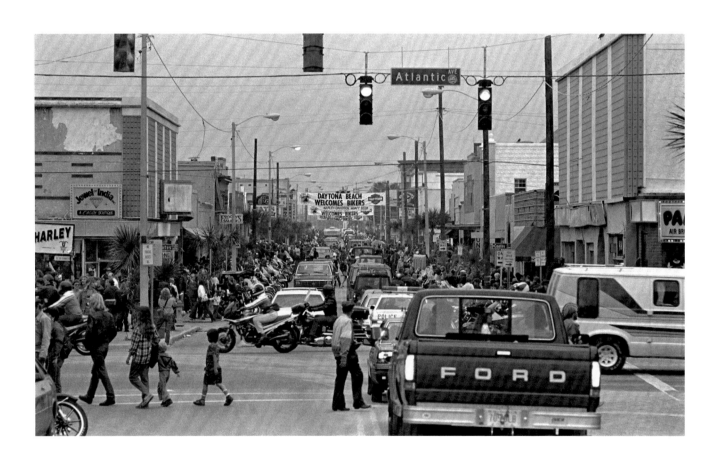

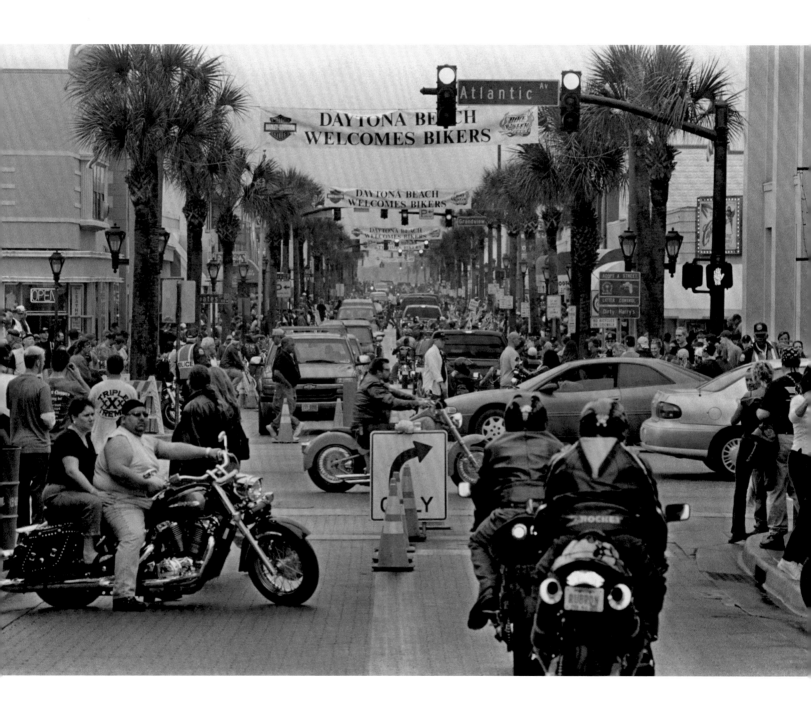

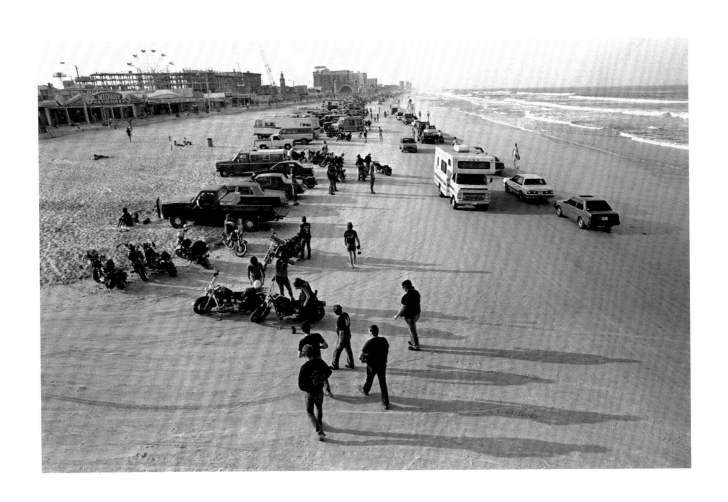

| *Beach at Main 1988*

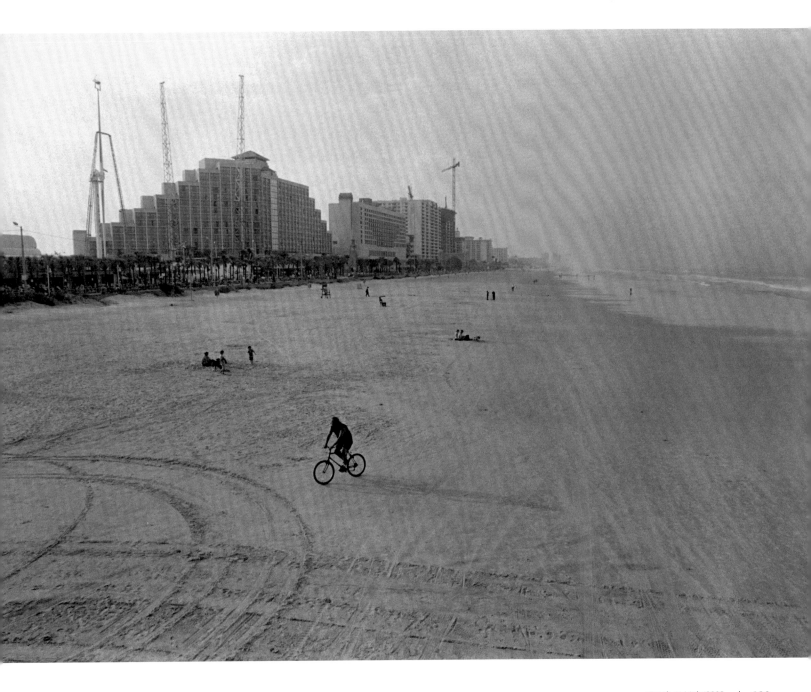

<em>Beach at Main 2003</em> | **109**

# The Pursuit of
# AUTHENTICITY

**Having spent the first weekend of Bike Week checking out some of the event's most popular locales, Monday I rode up to the Sunshine Holiday Camper Resort, located toward the north end of the Daytona area.**

There I found Jinks and Wolfpup, a couple of seasoned riders I had hooked up with weeks earlier in a motor-cycle forum on the Internet. I would be spending the rest of the week with Jinks and Wolfpup to get their perspectives on the changes at Bike Week and through-out biking. The online forum where we met is dubbed the Virtual Bar and Grill by its regulars. The VB&G is open to anyone with Internet access and provides a place for Harley enthusiasts to share "ride reports" on their extended journeys or day-trips; swap "wrench reports" on repair work, maintenance, and customiz-ing forays; or simply join in idle conversation, debate, and virtual shouting matches.

This afternoon Jinks and Wolfpup and their wives were getting ready to go riding with some friends—ten people on six bikes in all. I rode along, under a sunny sky and through crisp, cool air—perfect riding weather. We rode north, up a quiet stretch of Interstate 95; back down the canopied, two-lane Old Dixie Highway; across the Tomoka River and through Tomoka State Park; down Riverside Drive along the Halifax River; across the river and through the heart of Bike Week around Main Street; and finally down Route A1A to Ponce de Leon Inlet for an early seafood dinner.

Jinks, fifty-five, has been to every Bike Week since 1968. In all of those years only once did he not have a motorcycle. "That happens to almost everyone if they go long enough," he said. Jinks has been riding motor-cycles since he was in high school, when he and a friend bought a small bike. He rode small Japanese

motorcycles before working his way up to larger bikes and eventually to a Harley-Davidson. Given that Harley-Davidsons are among the larger motorcycles available, such a progression is not uncommon among Harley riders. This year he was rid-ing his 1986 Harley, a 1340-cc Low Rider.

Wolfpup, fifty, has been coming to Bike Week for only a few years, although he has been riding motorcy-cles since he bought his first Harley-Davidson in 1967. Since then he has owned various British and Japanese motorcycles and other Harleys. He also once co-owned a motorcycle shop. This year Wolfpup was riding his 1997 Harley-Davidson, a 1340-cc Springer Softail that he calls "Stokely."

Jinks was in his early twenties when he made his first trip to Bike Week. While in recent years he has stayed in his motor home, in past years he has stayed in a motel or camped in a tent. "I was up before the sun, and you had to knock me out to get me to quit for the day," he said. Back then, a single dealer show started early in the week, but it was aimed at shop owners and motorcycle dealers. Jinks said it was not until Thursday that the show opened to the public, and this was when the week began for most riders. "In 1968 Bike Week was a three- or four-day event," he said. Today it officially runs ten days, although many do not stay for the entire event.

In addition to the dealer show, Jinks used to go to the Rat's Hole Custom Chopper Show as well as the Daytona 200 at the Speedway on Sunday. In time, the dealer show ceased to have a restricted access period, and as the attractions grew the show splintered to var-ious locations around town, Jinks said. "Over the years

[the dealer show] evolved into the huge influx of vendors we see today," he observed. "The races remain and the vendors grow each year." While Jinks no longer goes to the races ("I'm just not a spectator sport fan"), the shows and vendor displays remain a central part of his Bike Week.

Indeed, Tuesday I rode with Jinks and Wolfpup to visit some shops and vendors. We started out at Miller's Custom Parts, a Harley-focused shop on U.S. 1 that anchors a stretch of vendors during Bike Week. We browsed the wares, I picked up some chain lube, and we moved on to the congested Beach Street area and the cluster of vendors that move in each year near the Harley-Davidson dealership. We were happy to find a few open curb spots for parking just off Beach Street. As we walked up to the corner, a rider turning slowly from Beach Street lost his balance and tipped over. Jinks quickly jumped off the curb to help him keep from going all the way down. Probably another "newbie," Jinks guessed, surmising that the rider may be one of many new riders taking to two wheels in recent years.

Jinks said the influx of new riders has been positive in some respects, resulting in more political influence, better machines, more product choice, and modern dealer facilities. And he said it has been negative in other respects, such as inflated prices, bigger crowds, and "more short-term riders that don't bother to learn the etiquette involved." Jinks said there is a greater need for experience and education. "The thing I find most disturbing about the new popularity of motorcycling is the inexperience of the newer participants," he commented. "Our sport has some inherent dangers. Inexperience, combined with ignorance, affects everyone that attends any of the rallies."

Jinks also has noticed much more cooperation between the bikers and police officers at Bike Week. "We can always find something to pick at, but the last few years of Harley success have brought more people, money, and respect into biking than the previous fifty years," he said. "Harley's success has been great for Harley, Bike Week, and motorcycling in general."

For Wolfpup, "the mass popularity of Harley-Davidson has meant larger and tamer crowds at all of the bike events." He agreed with Jinks that the increased flow of money has its benefits. "More money equals a good thing because it supports the aftermarket where I can buy go-fast goodies and such," he said. However, he is bothered by the number of "checkbook bikes" that he sees now. By that he means motorcycles that serve simply as "social jewelry" for those who seek the biker image, rather than bikes that are "extensions and demonstrations of the skills and abilities of their owners." Wolfpup described the "checkbook bike" trend as being similar to commissioned art that serves only to flaunt the wealth of those who largely lack an understanding of what goes into its creation. He views this as part of a troubling societal trend toward less individual independence and responsibility. "I think that we are . . . abdicating a certain kind of responsibility for our stuff, and by extension ourselves."

That afternoon Jinks found a new front axle cover, while Wolfpup decided to try out some translucent spark plug wires. "I like it that each year there's less stuff that I want for my bike," Wolfpup said. "It feels like it's close to being finished." Jinks's and Wolfpup's interest in parts and accessories reflects a strong customizing tradition among Harley-Davidson enthusiasts. It is typical for a Harley to undergo continued

modification and refinement. Harleys somehow "lend themselves to personalization more than other bikes," Wolfpup said. "No Harley is ever really finished." While this is the case today, in the 1960s and 1970s customizing was common among all motorcycle brands, according to Jinks. "Today, it's difficult to find parts to customize foreign bikes," he said.

Mechanical know-how, whether for customizing or, more important, for maintaining one's own motorcycle, is a salient value in biker culture. According to Wolfpup, bikers have "looked at themselves as the inheritors of the western outlaw tradition—rugged individuals living outside the mainstream, relying on themselves and their own wits and abilities to survive and prosper." For bikers, he said, "the minimum entree to that was doing your own maintenance." Jinks said maintaining one's own bike is part of the enjoyment of motorcycling, although it also is "for some an economic necessity." But for all riders, he said, the know-how to maintain your bike is valuable information to have when you run into trouble on the road.

In a 1995 study of the biker subculture, the western outlaw and folk-hero personae were identified as representing the core biker value of personal freedom. Central to this connection is "the Harley-as-horse metaphor, common in biker art, poetry, and fiction," according to authors John Schouten and James McAlexander. A Harley-Davidson motorcycle is often referred to as an iron horse. Indeed, one of the most popular bars in the Daytona Beach area is the Iron Horse Saloon. "Symbols of frontier liberty and license are supported further by biker clothing and accessories with western motifs, including leather chaps, boots, vests, and saddlebags, often adorned with fringe," note

Schouten and McAlexander. "Similarly, symbols such as the tattoos, long hair, and bushy beards of many bikers, especially working-class members of the baby-boom cohort, signify liberation from mainstream values and social structures."[1]

Such liberation tends to be closer to myth than reality, Schouten and McAlexander observe. Nonetheless, the myth serves as a core value in biker culture and as an idealized counterpoint to the reality of various forms of confinement in family, community, and society. Adherence to the liberated ideal may be seen in the ongoing struggle against helmet laws (Florida repealed its thirty-year helmet law in mid-2000) and in the exhibitionism at biker gatherings. Public displays of nudity and sexuality have long been commonplace at Bike Week, whether in the organized coleslaw or mud wrestling, dancing, and wet T-shirt contests or in the random acts of individuals at bars, on Main Street, and on the beach.

Wednesday morning I met Wolfpup and his wife, Ms. Mouse, for breakfast before joining them for a ride back out to the Cabbage Patch to check out the coleslaw wrestling, the bar's signature event. Although relatively new to Bike Week, Wolfpup and Ms. Mouse have found favorite ways to spend their time. But they had not yet experienced the slaw wrestling, so this year they wanted to witness the spectacle. Wolfpup said they usually enjoy frequenting several bars, including the Iron Horse Saloon. "We always do the Harley show," he said, "though it's mostly because we hang with Jinks and he likes it." He said they visit Main Street at least once, and they "do the vendor thing" with Jinks. Wolfpup said he enjoys seeing the other motorcycles at Bike Week, both on the street and at

the shows. "I like the noise. I like the fact that the bikes outnumber the cars," he said. "I like the two or three bikes each year that just set me on my ear with their fresh design and creative engineering."

Arriving early at the Cabbage Patch, we had to wait in a holding area for more than an hour, penned in among so many black leather jackets like corralled livestock. Once inside the gate, we took seats in the bleachers surrounding the slaw pit and waited for more than another hour. Meanwhile, very loosely organized opening entertainment kept the crowd in agreeable spirits. Large quantities of consumable spirits also kept the crowd contented while at the same time making it potentially more volatile. One young woman in the stands who looked ready to tip over finally answered the pleas of countless men around her by baring her breasts, while her more sober friend labored to maintain control of the situation. The wrestling contestants, all female, took turns sitting astride an idling Harley-Davidson and simulating sexual pleasure while the throttle was revved. Countless breasts were bared and even a couple genitalia, of either sex. Finally, from a plane overhead appeared two falling specks. Parachutes soon opened, and the first skydiver veered off course to land in an adjacent field. The second skydiver landed right on target in the middle of the ring to enthusiastic cheers from the excited crowd.

The wrestling eventually began. Bout followed bout, and it appeared that many in the crowd wore out well before a coleslaw-wrestling champion was determined, as if that mattered anyway. Among those departing early were Wolfpup and Ms. Mouse. "It's kind of stupid and panders to the worst of behavior," Wolfpup said. "I thought it was base and degrading, quite frankly."

Machismo is one of the core biker values identified by Schouten and McAlexander. "In this patently masculine subculture the roles of women traditionally have been subordinate at best to men," they write. This status is widely evident at Bike Week, manifested in the woman's traditional place on the back of the man's motorcycle and in the widespread and overt objectification of women. It was 2001 before I saw my first female-driven motorcycle with a male passenger on the back. They were idling their way down crowded Main Street and were the object of much attention—which was obviously due to their seating arrangement.

Nevertheless, among the newcomers increasingly infiltrating the old culture are many female riders on bikes of their own, something that has not drawn unusual attention in many years now. "Recently I see more and more input from women," said Janet Kersey, of the local Convention and Visitors Bureau and a lifelong Daytona resident. "I think the influence of women on [Bike Week] has been huge and has directly affected the entire market," she said. "[Women] actually changed the event from the mystic 'bad-boy-in-black' image to one of an event for the entire family." Kersey said she has not heard any complaints about the way women are treated at Bike Week. Nevertheless, sex objectification does not appear to be in decline. Rather, it seems that this is one old biker tradition that newcomers are more than happy to maintain. If there is change in this area, it may only be that women are more likely to objectify men in return.

Jinks and Wolfpup downplayed the extent of machismo. Asked about it, Jinks simply said he sees no problem with the increase in women riding their own

bikes. Wolfpup agreed, adding that Ms. Mouse was considering a bike of her own. "I think it's great," he said. "I'm all for women riding. I think it's sexy and attractive." Jinks's wife, Linda, followed him into biking and now happily considers herself a biker even though she doesn't ride her own machine. While acknowledging that there remains a lot of overt sexuality at Bike Week, Linda pointed to the improved climate brought on by increased equality. While some women still choose to play by their sexuality, she said, women today are able to attend Bike Week as equal participants—as riders, enthusiasts, and shoppers.

Another core biker value named by Schouten and McAlexander is patriotism. "To the extent that the Harley-Davidson motorcycle represents personal freedom, as the sole survivor of the American motorcycle industry it also represents America," they observe, writing just before the recent surge in American upstarts. Like the United States itself, Harley-Davidson employs an eagle as its primary symbol. The company also has incorporated various forms of the American flag in its marketing. The flag is displayed in numerous ways throughout biker culture, whether on pins and patches or flying on the backs of motorcycles. At the time of each war against Iraq, at Bike Week 1991 and Bike Week 2003, patriotic symbols and support for American troops were particularly prominent, as was anti-Iraq sentiment. High levels of patriotism among bikers may stem from the historically large number of veterans who have ridden Harleys and who constitute a significant subset of Harley riders. Additionally, Harley-Davidson has long capitalized on its position as the sole American motorcycle manufacturer for nearly a half century.

Biker patriotism has long taken the form of antipathy toward Japanese motorcycles. Popular events at Bike Week include the Bike Bash and the Bike Drop. The Bike Bash, where participants take turns with a sledgehammer, is held at Pub 44 in New Smyrna Beach. "It began in 1981 when the economy was bad, the crime rate was sky-high and the trade deficit was through the roof," said owner Gilly Aguiar. "We decided to bash a Japanese bike."[2] At the Cabbage Patch's Bike Drop, a Japanese bike is drained of its oil, its engine is cranked, and it is raised 125 feet into the air with a crane. The bike is left running until it seizes, then it is repeatedly dropped until it is a mangled mass of metal. The vanquished motorcycle finally is set aflame, and the crowd dissipates, some tossing their beer cans onto the charred heap.

Another reason why Japanese motorcycles (also derisively known as "rice burners" or "crotch rockets") are scorned by bikers, according to Schouten and McAlexander, is the perceived lack of respect for tradition among Japanese manufacturers. "Harley-Davidson, in contrast, emphasizes a continuity that connects its newest motorcycle in a direct line of ancestry to its earliest prototype," they note. Thus there is the popularity of retro-fashioned models in recent years, as well as the aversion among many Harley riders to new technology. The 2001 arrival of liquid-cooled engines, heretofore unseen on a Harley-Davidson, had some Harley hard-liners concerned. But as with electric starts, occasional engine redesigns, and no doubt even

earlier developments such as rear suspension and foot shifters, liquid cooling, too, likely shall pass.

Jinks and Wolfpup downplayed the connection between Harleys and American patriotism. They each owned more than one Japanese bike along the road to their current Harleys. "If [Harleys] fit your style, fine," said Jinks. "If another brand fits you better, then that's also fine." Wolfpup agreed that Harley riders tend to be conservative about motorcycle technology. "We're deeply suspicious of anything to do with our bikes that would keep us from being able to fix them by the side of the road in Elk Lip, Montana, with a fence post and a Buck knife," he said.

Thursday I joined Jinks and Wolfpup for the half-hour ride southeast to the Volusia County Fairgrounds. This was the site of the annual swap meet, a sprawling flea market devoted to motorcycles. We spent two or three hours, inside and out, browsing motorcycle parts and accessories of every variety. Jinks found a few parts to refurbish his bike. He noted that compared to previous years, there were fewer vendors selling collectibles and more vendors selling new parts. Wolfpup found an old-fashioned oil filter canister but wasn't sure how he might mount it on his bike. Fairground activities run all week, featuring auctions, stunt shows, and other bike shows, such as "side car and trike day" and "antique bike day." We didn't catch any of that. Instead, we rolled east on State Road 44 toward the ocean. About twenty miles later we were at Pub 44 in New Smyrna Beach. This was the day of their "18th Annual Bike Bash," which stretches impossibly from noon until midnight. We enjoyed a little refreshment and roamed the crowded grounds for a while before heading north to Daytona Beach again via U.S. 1.

Afternoon traffic was picking up by now, and it was a little cooler as the sun dropped to our left. The weather had been very nice so far this week, with clear blue skies and comfortable temperatures. That meant T-shirts while on foot and a jacket while riding, especially at night. In other words, perfect biking weather. It was nice getting out on the road for a few good miles this day.

Jinks and Wolfpup agree with the notion of the deviant biker image arising in postwar America. "The men returning from World War II . . . gave the deviant theme a good start with their dropout attitude," Jinks said. "Follow that with a liberal dose of movie and media moneymaking, and 'biker' was a foul word for nearly four decades." The growing popularity of motorcycling in recent years has helped offset the deviant image, Jinks said, "but there will always be those that cling to the deviant label." Wolfpup said the postwar bikers represented "a kind of assault on the senses" because their behavior and appearance were different from what was perceived as normal by the mainstream middle class.

Baby boomers coming of age in the 1960s and 1970s bought motorcycles in large numbers. But they tended to buy cheaper Japanese motorcycles, which were burdened with neither the poor mechanical reputation that Harley-Davidsons then had nor the negative biker associations surrounding Harleys. "You meet the nicest people on a Honda," said Honda's familiar advertisement of the time, in an effort to counter the biker image that reached beyond Harley-Davidson. According to Jinks, the effect of the increase in riders during the 1970s was almost unnoticeable compared to what happened in the 1990s when the baby boomers returned, this time seeking Harleys.

Back in the dark days of 1981, when Harley-Davidson wobbled very unsteadily away from American Machine and Foundry, then-chairman Vaughn Beals recognized at least the potential for baby-boomer spending. "It's good for us that the baby boomers are getting older," he said at the time. "We've always had an older clientele—the guy who gave up riding when he got married, who returns in his late thirties along with his wife."[3] Although Harley sputtered for several years, by the late 1980s Beals's words were starting to look prophetic. Then in the 1990s, Harley-Davidson's success was so complete as to transform biker culture. "A lot of the riders in the past ten years have been more affluent than riders—particularly Harley riders—have ever been," according to Wolfpup. "It makes a lot of difference."

Media reports chronicled the shift, often with headlines such as "A Hog Is Still a Hog, but the 'Wild Ones' Are Tamer."[4] There was widespread consensus that the baby boomers were largely responsible, even if more precise explanations varied. "The average age and income of motorcycle enthusiasts is [sic] increasing as baby boomers, deep into midlife crisis, rediscover the joys of blasting down a highway," said *Business Week*. "Today's economy displays many signs of robust 'boomer consumerism,'" noted *American Demographics*, describing roaring motorcycle sales.[5]

Indeed, it was suggested that motorcycling was just another market niche to feel the impact of the massive baby-boomer demographic passing along its life course. "Nearly every great marketing coup of the last fifty years has involved feeding the appetites of [the baby-boomer] army, male and female alike, as it has moved through life," observed *Esquire*. "The products are

familiar to us all, from disposable diapers to rock 'n' roll, from portable hair dryers to personal computers."[6] In this case, the thriving economy was contributing to strong personal spending, and motorcycles were proving to be an attractive leisure purchase compared to higher-maintenance and more time-consuming options such as boats. Flourishing sales of recreational vehicles during the 1990s were additional evidence of the popularity of automotive-related leisure pursuits. Touting the benefit of Harley-Davidson's soaring stock, another article said, "A Harley-Davidson gives you a half-hour vacation instantaneously."[7]

The Harley-Davidson Motor Company's own figures verified that the profile of the typical Harley buyer had shifted to fit the aging baby boomer. The average age of Harley buyers increased by eleven years to 45.6, and buyers were more likely to be married. Between 1987 and 2001, the median household income of Harley buyers more than doubled, reaching $78,000. More college graduates (and fewer high school graduates and those without a high school diploma) were buying Harleys. These figures revealed a general trend among Harley buyers toward higher status as reflected by age, income, and education.

For motorcycling, as elsewhere, the aging of the baby boomers has coincided with a muddling of what, through the postwar decades, was a relatively straightforward dichotomy between the conforming establishment and the rebelling antiestablishment. The latter took various forms, including beatniks and hippies and bikers and rebels. Author David Brooks has labeled the new blend the "Bobo," that is, part bourgeois and part bohemian.[8] Brooks said the Bobo ethic is a sometimes-confusing mix of both rebellion and conformity.

"Bohemian attitudes from the hippie 1960s have merged with the bourgeois attitudes of the yuppie 1980s to form a new culture, which is a synthesis of the two," Brooks comments. For a time, these two cultures were at odds with each other, "but while the culture warriors were arguing with each other, regular Americans were adopting attitudes and lifestyles from both."[9]

In the new synthesis, for example, we see major corporate interests advertising themselves with antiestablishment anthems of the 1960s such as the Beatles' "Revolution" and Steppenwolf's biker anthem, "Born to Be Wild," and with antiestablishment icons such as Gandhi or Jack Kerouac. The upscale consumer has developed cultural tastes reflecting a formerly counterculture consciousness. "This isn't just a matter of fashion accessories," Brooks observes. "If you investigate people's attitudes toward sex, morality, leisure time and work, it's getting harder and harder to separate the antiestablishment renegade from the proestablishment company man."[10]

Brooks's "Bobo" synthesis well describes what has occurred with the ascendance of the new bikers. Wolfpup suggested that for some who chose the conformist route decades ago, there may have been a lingering romanticism connected with the rebellious world of motorcycles. By the 1990s, these baby boomers had more disposable income, and their children were leaving the nest. Encouraged by Harley-Davidson's new marketing, the middle-aged baby boomer who shied away from the deviant biker image as a teen or young adult realized "he really could be a dangerous guy if he wasn't busy polishing bicuspids," as Wolfpup put it. "Attorneys, accountants, dentists, and so on are dressing up like the people that used to scare them because it's romantic," Wolfpup said, adding that such higher-status participation in biking has made it more acceptable for others to follow along. So many new riders are choosing Harley-Davidsons over less expensive bikes and those offering more technology, Wolfpup said, due largely to the biker image. "That and the fact that because of their engine design, nothing else feels like a Harley," he added. "There's something primal about it and to the folks who feel that, nothing else will replace it." Jinks agreed, noting Harley's "very well managed image, their simplicity, and surprisingly their reliability. They are one of the most comfortable yet visceral rides in the world."

The initial and persistent response to the new bikers could be found on a popular black T-shirt: "Die Yuppie Scum." But such outright disdain softened as the newcomers kept coming and increasingly infiltrated the biking ranks. To some extent, the newcomers simply represent the new wave of bikers, adapting to the subculture and at the same time altering it in its own way. In a more immediate sense, the less committed of the newcomers are merely interlopers who have little in common with their predecessors but nonetheless seek to get in on the perceived excitement surrounding the subculture. With so much activity around the edges of the subculture, varying levels of commitment among the newcomers and a heightened concern with authenticity by the old guard are to be expected.

As the newcomers increasingly immerse themselves into the subculture, their commitment to it is demonstrated in various ways, and their authenticity is measured accordingly. "Status is conferred on members

according to their seniority, participation, and leadership in group activities, riding expertise and experience, Harley-specific knowledge, and so forth," according to Schouten and McAlexander. "Visible indicators of commitment include tattoos, motorcycle customization, club-specific clothing, and sew-on patches and pins proclaiming various honors, accomplishments, and participation in rallies and other rider events." Of course, many of the visible signs of commitment may be appropriated with little actual involvement in the subculture. Black T-shirts and leathers may be quickly donned to affect the biker look. With a little more effort one can acquire facial hair and tattoos. Temporary tattoos, being easy to apply and requiring less commitment, have become popular in recent years.

The concern about authenticity is demonstrated in the use of the derogatory label "poseur" for those who, for whatever reason, are deemed less than properly committed. Jinks distinguished between a biker and a poseur by simply describing the former as "a person that owns and rides a motorcycle" and the latter as "the person that needs to buy a lifestyle." He added: "Fifteen thousand dollars, fifteen miles, and a new T-shirt don't make you a biker. But new leathers and a new scoot don't make you a poseur either—unless they're both still new at the same event next year." Wolfpup, although reluctant to polarize bikers and poseurs, offered that a biker is "anyone who is serious about motorcycles and motorcycling," while a poseur is "someone who isn't serious about motorcycles or motorcycling but wants other people to believe that he or she is serious about it."

Biking has become more accessible and appealing to casual riders, not only due to the softening of the biker image but also due to the technological advances that make biking easier. These vary from more user-friendly and low-maintenance bikes themselves to comfortable riding gear such as waterproof suits and electrically heated apparel. With an increase in casual riders costumed like hardened veterans, the extent of one's riding becomes a more useful measure of whether one is a biker or a poseur. For the most fervent traditionalists, anything short of riding is unacceptable, and the odometer tells it like it is. Like many salient biker sentiments, this one has been reduced to a popular slogan on a black T-shirt: "I rode mine."

Riding a motorcycle is a very different experience than driving a car. The singular qualities of motorcycling set apart those who ride, giving them a sense of camaraderie with each other and against the dreaded cagers—those enclosed in vehicles with four or more wheels and who often seem to drive as though they have motorcyclists in their crosshairs. The riding experience includes the visceral thrill of handling a motorcycle and the camaraderie of riding with others, as well as the potential discomfort of poor weather and perilous traffic. It includes meeting the physical and mental requirements of a more rugged mode of transportation, successfully avoiding the many and often dangerous obstacles encountered along the road and making do with the limited storage space on a motorcycle. "I don't think that I ride because it makes me part of a subculture and separates me from the herd, but I do know that I like the fact that it does," Wolfpup said. "It's sensual. Riding informs my life and illuminates my time." Of course, most who ride also drive cars or trucks. Ideally, these temporarily caged riders are making the best of their predicament by infiltrating the caged masses and

safeguarding the passage of their true comrades, the vulnerable two-wheelers around them.

Friday we rode down to the Daytona International Speedway. In addition to the numerous vendor displays set up outside the track, the site has various demo rides and a few small stunt shows. We walked across busy International Speedway Boulevard for lunch at Hooters. Eating burgers and fries on the outdoor covered patio, we were entertained by occasional smoking tires and burning rubber in the parking lot. Apparently, elaborate departures are de rigueur here. One guy very nearly forgot to remove his front disc lock before beginning his dramatic departure. That could have been more drama than anyone had bargained for.

Among the many vendors visited at the Speedway, Jinks, Wolfpup, and their wives spent a couple hours looking at the trailer exhibits. These weren't strictly your basic two- or three-bed, open bike trailers. Some models were quite involved, including motor homes with a built-in motorcycle garage. Motorcycle trailering is among the more high-profile topics in the ongoing tension between bikers and poseurs. Trailering simply refers to towing one's bike to a destination rather than riding it there. Trailering has become so commonplace at Daytona Beach that many now sarcastically refer to the event not as Bike Week but as Trailer Week. In the general opinion of bikers, trailering is at best a sometimes practical, though not preferred, method of transportation and at worst an indefensible betrayal of the very purpose of owning a motorcycle, which would be to ride it.

While Jinks and Wolfpup ride their motorcycles to some events, they opted not to ride the relatively short distance from their homes to Daytona Beach this year.

Jinks pulled his motorcycle in an enclosed trailer behind his motor home. Despite the sometimes unreasonable antitrailer sentiment among many bikers, Jinks and Wolfpup are comfortable with their use of trailers. "The majority of the antitrailer crowd is young, inexperienced, and has a very narrow view of the world," Jinks said. "Riding is a very personal experience," he added. "How you enjoy it affects nobody but you." He favors being open-minded about trailering, saying that riders should have respect for the decisions of other riders. While he understands the desire to promote riding among motorcyclists, he thinks the debate should not be as "rabid" as it often gets.

Wolfpup carried his motorcycle to Bike Week in the back of his pickup truck. "I haven't yet figured out how to tow my travel trailer behind the bike, so [the bike] has to ride in the truck when I'm taking the trailer that we sleep in," he explained. As for antitrailer sentiment, Wolfpup said that it is nobody else's business what he does with his bike and that he is not interested in others' opinions on the matter. "It's a ridiculous conversation, and [it] has a lot more to do with chest-thumping and pulling peoples' legs than it has to do with reality," he commented. Wolfpup acknowledged the spirit of the antitrailer stance. "Even among those of us who trailer or truck a bike on occasion, there's a tacit understanding that riding . . . is part of the purest experience," he said. "To me the ride is more important in a lot of ways than the actual destination."

There are far more Harley-Davidsons on the streets than there were a decade earlier, and the sudden influx of new riders presents a threat to the stability of traditional biker values—particularly due to the large number of new riders, their affluence, and their potential

lack of commitment to the subculture. For example, new riders who have greater means to pay others to work on their bikes, which furthermore are more reliable today, have little incentive to learn about motorcycle maintenance. Such skills also may be of little value to those simply riding the wave of motorcycle popularity and who are not likely long-term devotees.

Customizing, on the other hand, is a tradition more readily pursued by newcomers. Indeed, the customizing possibilities are limited only by one's budget. Harley-Davidson has broadly expanded its range of accessories to offer additions or alterations for every facet of the motorcycle. The proliferation of chrome accessories, especially, is viewed by many today as an exaggerated distortion of a traditional Harley characteristic. For example, the Motor Company now offers chrome "trim" parts that cover other parts rather than replace them, thus offering a merely cosmetic chrome look for relatively little cost. The famous Panhead chopper from the film *Easy Rider* set the high-water mark for chrome. That was then. Now chroming is an issue on which a few traditionalists have chosen to fight the battle against the new bikers by favoring instead a predominantly black profile for their bikes— not only black paint jobs and black leather seats but black engines, black pipes, and black accessories.

Wolfpup said the increased affluence among the new wave of Harley riders results in some resentment on the part of longtime riders who have been among the "disenfranchised and the underachievers economically and in terms of social status. Suddenly the 'haves' of our society are buying Harleys at such a rate that they are driving them out of the reach of the chronic 'have-nots,'" he said. "And to add insult to injury, they are dressing and trying to act like the 'have-nots.'" But Wolfpup said his own feeling on the matter is more simply one of "contempt for most anyone who pretends to be what they are not."

Internet forums are places where it is very easy for people to pretend to be something they are not, and the online forum frequented by Jinks and Wolfpup—the Virtual Bar and Grill—has its share of unknowns and miscreants. But for a community based around a mode of transportation, it is not surprising that VB&G regulars like to meet "in real life" with their online compatriots, who may live across town, across the country, or even across the globe. Saturday at noon we rode to Smiley's Tap, just up the road from the Iron Horse Saloon, for the annual Daytona gathering of VB&G patrons. Members also may meet at gatherings, large and small, anywhere else throughout the year. Upon arrival, Jinks and Wolfpup immediately began connecting a few unfamiliar faces with familiar names and spotting friends already known in person.

Especially for its regulars, the VB&G is indeed a virtual biker bar where newcomers are expected to keep a low profile by "lurking" until they understand the establishment's customs and then introduce themselves and "buy drinks" for the group. An imagined barmaid, purportedly named Shirley, can help with the latter. Online biking groups "are one of the best things to happen to motorcycling," said Jinks, who signs off with the designation "#64" next to his name. This means that he is Asshole #64, the sixty-fourth member of the group's so-named elite rank. Region-based subgroups in the VB&G also issue numbers, but the Assholes are the most respected of the group's participants.

Jinks said he has met more people—locally, nationally, and even internationally—online and in subsequent real-life meetings than would ever be possible otherwise. The VB&G "is the only online group I know of that makes a concerted effort to meet in person," added Wolfpup, Asshole #62. "Our bond is riding." The VB&G has held several annual rallies of its own, called "Meet in the Middle" and centrally located near St. Louis. This and similar, smaller rallies are thought by many to capture a more authentic spirit from a somewhat idealized past—long before major events such as Daytona and Sturgis became so popular, crowded, and commercialized.

After a couple hours at Smiley's, we rode to the Ocean Center Arena, a few blocks from Main Street, for the Harley-Davidson Expo. In the large, air-conditioned, carpeted hall, people gathered around to look at and sit on numerous shiny new Harley-Davidsons, as company representatives stood by to highlight their finer points. On display was every model of bike as well as all kinds of accessories and other items such as cleaning supplies and apparel.

Next, we walked next door to Adventure Landing, this year's site for the annual Rat's Hole Custom Chopper Show, hosted by Karl "Big Daddy Rat" Smith. Sitting next to Big Daddy Rat at a raised table, retired stunt rider Evel Knievel signed autographs for a line of fans. We strolled through the outdoor water park, examining the wild array of customization—from frame design to engine setup to paint work—on bike after bike.

By late afternoon, the group decided to walk the few blocks to Main Street to make a first appearance there on this last full day of Bike Week. Our first stop was the Boot Hill Saloon, raucous as usual, where we enjoyed some beers in the fading light at the large front window. We wandered up Main Street after dark, browsing among the many shops and their sidewalk displays and taking in the parading action in the street. After finishing our Main Street visit with a stop at the Full Moon Saloon, we ended the long day with a big Mexican dinner near the Speedway.

A generation ago it would have been possible, despite the inevitable exceptions, to generalize about the biker subculture as a predominantly white, male-driven, working-class-based, individualistic group. This was the subculture of individualism, patriotism, and machismo identified by Schouten and McAlexander. The arrival of the new bikers has altered this characterization, making the biker subculture much more heterogeneous.

Schouten and McAlexander sought to define the new biker subculture as a "subculture of consumption," that is, "a distinctive subgroup of society that self-selects on the basis of a shared commitment to a particular product class, brand, or consumption activity." The authors said that a consumption-based self-identity transcends ascribed identifications based on such primary sociological categories as class, race, or sex. Supporting evidence is found in the broadening demographic of Harley-Davidson owners and Bike Week participants—by class, race, and sex. "It is now widely believed that consumer goods provide an opportunity for people to express themselves, display their identities, or create a public persona," according to author Juliet B. Schor. "Who we are not only affects

what we buy. What we buy also affects who we become."[11]

Identification with any subgroup—whether ascribed groups such as race and sex or achieved groups such as a subculture of consumption—serves as a powerful means of determining one's self-identity through association with certain others. Adopting the biker self-identity is a process of socialization and increasing commitment to the subculture, as Schouten and McAlexander found. It begins with experimentation, followed by identification and conformity, and finally mastery and internalization. However, to the extent that the biker subculture has diffused, mastery and internalization come in varying areas and degrees, the result indicating the type of biker that one will be.

Among various influences, the active role of Harley-Davidson's marketing in the socialization of the new biker means that many newcomers are entering the culture with a somewhat different set of values than did those who came before them. "Because the newcomer is ignorant of many nuances of biker culture, his or her socialization may be facilitated opportunistically by marketing efforts," write Schouten and McAlexander. They note how new Harley-Davidson owners are targeted with promotional literature and catalogs and are automatically admitted to the Harley Owners Group (HOG), the numerous local chapters of which provide ample opportunity for socialization among peers. "This socialization process," Schouten and McAlexander conclude, "has the effect of molding the malleable perceptions of the new biker toward an acceptance of the corporate vision of bikerdom and of creating customers for official Harley-Davidson clothing and accessories."

It is not surprising, then, that HOG membership has been attacked for its connection to the changes in the biker subculture, just as have the "boutique" Harley dealerships, their clothing and accessory lines, and anything else connected with the new wave of biking. Nevertheless, Harley-Davidson's increased marketing presence has coincided with, and undoubtedly been a significant factor in, the booming popularity of Harleys and the general interest in biking culture, whether old-style or new.

Thus the old biker subculture has been co-opted by elements of mainstream society. Harley-Davidson itself entered this game with their "factory custom" motorcycles, starting with the 1971 Super Glide, the first of many Harleys to reflect the chopper styling then popular among bikers. Later models took the names of the two preeminent biker gatherings, first the FXB Sturgis and then the FXDB Daytona. The 1980 Sturgis was "perhaps the first openly commercial attempt to connect with the outlaws," according to author Brock Yates.[12]

The 1983 organization (and trademarking) of HOG was another step in the co-optation of biker culture. "It was formed in part to counteract the dissident Harley-Davidson Owners Association and in part to coalesce new customers," according to Yates. "This involved a radical turnabout in policy in that the heretofore pejorative 'hog' was embraced as a self-effacing, irreverent corporate nickname." Yates suggested that even the early 1980s Evolution engine redesign, with its enhanced technological sophistication, played a role in the co-optation. "It opened the door to even more tyros and wanna-bes with no mechanical knowledge who could now elbow into the scene."[13]

Such an invasion of a small subculture by larger, moneyed interests is nothing unusual. One example found not far from biking is the popularization of stock car racing. Formerly considered a predominantly southern and working-class pastime, NASCAR racing has moved upscale with its considerable growth not only in the South but also across the nation. As in biking, longtimers express some distaste for more upscale newcomers and the changes they bring with them.

Other examples include the fashion and music industries, which are regularly subject to cycles of subgroup co-optation. Blue jeans moved from working-class standard to 1950s symbol of rebellion and, in subsequent decades, to fashionable designer jeans and all-purpose practicality. The commercialization of rap music is a recent example, in the wake of jazz and rock 'n' roll, of how the mainstream may overrun a subcultural, and perhaps countercultural, element of society.

Similarly, the biker subculture began as a deviant one and was shunned by Harley-Davidson for many years throughout the 1950s and 1960s. The company began making gradual moves toward the subculture in the 1970s and then fully embraced it in the 1980s. In the 1990s, Harley-Davidson reaped the rewards. The task, as Schouten and McAlexander put it, was "to expropriate certain symbols of the outlaw subculture and employ the product design and advertising components of the fashion system in order to redefine their meanings just enough to make them palatable to a broader group of consumers."

Marketing efforts to shape the image build on the strong patriotic tradition while softening the machismo just enough to invite women into the riding ranks. The real-life outlaw or maverick is replaced by a merely rebellious image, where the biker look and a sense of rugged individualism are preserved in order to maintain the biker mystique. But absent are any connections to explicit illegality or outright rebellion. "Harley-Davidson has co-opted important symbols and structural aspects of the outlaw subculture, sanitized or softened them, and given them more socially acceptable meanings," write Schouten and McAlexander.

Of course, excessive co-optation risks destroying the very qualities that initially make the subculture so appealing. "As membership in the subculture becomes more accessible and acceptable to mainstream consumers, and as more mainstream consumers begin to don the trappings of bikers, lines of marginality become blurred and some of the distinctiveness of the biker subculture is lost," Schouten and McAlexander observe. More immediately, Harley-Davidson risks tarnishing itself with a commercial artificiality that contradicts the very individualism that is supposed to flip a middle finger toward crass commercialism.

Thus weathered traditionalists often deride the newcomers as poseurs, and many longtimers feel that the "MoFoCo" and its "stealerships" are unfairly squeezing out many tighter-budgeted loyalists like themselves in favor of yuppie poseurs. According to Schouten and McAlexander, Harley-Davidson "is faced with a veritable tightrope walk between the conflicting needs of two disparate but equally important groups of consumers: those who give the product its mystique and those who give the company its profitability."

During Bike Week at Daytona Beach, it increasingly appears that the profitability factor is up and the mystique factor is down. This hegemony of marketplace values may be seen as either a positive or a negative

development. The sociologist George Ritzer has described what he perceives as the increasing rationalization of society.[14] Ritzer is concerned that certain developments that are pursued according to a seemingly reasonable (rational) basis may in fact be narrow calculations that ultimately create harm and are paradoxically irrational.

Ritzer begins with the rise of the streamlined fast-food business in the last half century, the organizing principles of which have spread throughout other sectors of society. Wherever employed, this "McDonaldization" has achieved such intended and desirable goals as greater efficiency and predictability. But there also have been unintended consequences, such as lost creativity and lost autonomy due to increasing bureaucracy and mechanization and the threat to individuality and multiformity that comes with increasing homogenization. Just a few of the irrational outcomes cited by Ritzer include cookie-cutter housing subdivisions, routinized assembly-line work and scientific management procedures, sound-bite politics and news presentations, and unhealthy fast food.

Applying Ritzer's concerns to Bike Week, it is rationally appropriate that as the event has become so popular, many aspects of the event have been altered. There may not be as much freedom to do as one pleases, but crowd-control measures—especially by law enforcement and bar security—help to ensure that the event goes smoothly overall. Increased control reduces the likelihood of driving under the influence, motorcycle theft, accidents, fights, and other troublesome events.

At the same time, increased control has reduced or eliminated other less harmful aspects of Bike Week, such as sleeping on the beach, driving on the beach, and exhibitionism. Whatever the merit of these and numerous other changes both large and small, the fact of their occurrence signifies a real change in the atmosphere at Bike Week. Such changes are rational in that they generally permit more people to have a pleasurable experience at Bike Week. They are irrational in that they have tended to homogenize the event, suppressing the outlandishness that distinguished Bike Week and made it all the more appealing for some.

Much about Bike Week that has been discussed may be considered in terms of rationalization. For example, trailering is a rational response to poor weather, limited luggage space, and other concerns. However, the increased control, predictability, and efficiency afforded by trailering also mean that traveling to Bike Week loses its distinctiveness. Missed is the opportunity for a more sensational journey that would provide a more complete motorcycling experience—experience that has long been celebrated and around which the event was originally organized. Instead, it is just another trip in the car, irrationally to an event where actual motorcycling may be only a pose or an afterthought.

Similarly, biking attire in many cases has been distanced from its original purpose. Leather garments are intended to protect riders from the cold and the wind and to protect the skin in case the rider goes down. Denims are durable and tend to hide the dirt and oil stains that riders inevitably collect. Today, these clothes are often worn as fashionable costumes where there is little chance they will serve their utilitarian functions. Moreover, the masquerade may be embellished with a temporary tattoo.

In these and other ways, Bike Week has been subject to a process of overrationalization. It has been posited that the culture of biking, having formed and grown through the 1950s to the 1980s as a subcultural element within American society, by the latter decade had begun changing due largely to the aging of the baby-boom generation. This underlying demographic shift and its attendant cultural manifestations fostered a change in the meaning of biking, from a primarily deviant one toward one of mainstream normality. Subsequently, a different response toward biking from the city of Daytona Beach and from society in general became feasible, and it in turn fueled the changes already occurring. The receptive stance taken toward Bike Week by Daytona Beach and by Harley-Davidson, in the form of promotions and advertising, translated into far greater participation in the shifting subculture.

As expressed by longtimers such as Jinks and Wolfpup, there is a concern about the degree to which authenticity has suffered as biking and Bike Week have become increasingly mainstream and commercialized. "Daytona has become a regular fuckin' motorcycle Disneyland, which is why I usually don't go anymore," said another regular of the Virtual Bar and Grill. This criticism looks more prescient when considering the growth possibilities of a new Orlando Bike Week in the shadow of Disney World. Indeed, Bike Week often does look like a fantastic theme park, one where bikers, poseurs, and nonbikers alike come to sample a commercialized version of biker culture and revel in the carnival-like atmosphere. Call it Biker World.

The last Sunday at Bike Week always has a sad feel about it. When the sun rises, Main Street is suddenly just another city byway with plenty of available parking and an eerie quiet. No longer is it the heart of ceaseless action shooting its lifeblood on two wheels throughout the region—across the river to Beach Street, up to the Iron Horse and beyond to Flagler County, out to the Speedway and farther to the Cabbage Patch, and down to New Smyrna Beach. In a symbolic farewell each final Sunday morning, an impossibly long stream of bikes parades south along Route A1A, past Main Street, and inland on International Speedway Boulevard to the Speedway, site of the Daytona 200 race later in the day. The area's population declines so rapidly that one can practically feel the exodus. It's not the best day to be northbound on Interstate 95.

I packed up and loaded down my bike with the requisite precision, aided by my assortment of indispensable bungee cords. Once again, it was time to ride. I cross the river to the mainland and head north, past the now-tamed Iron Horse, to Jinks's and Wolfpup's campground. They are loading their bikes and getting ready to depart as I arrive, and we have a last visit and say our farewells. They have been most helpful in sharing their Bike Week experience these last several days. It's been a great pleasure riding with them this year—all the casual conversations, shared meals and drinks, and miles along the road.

For the first time in a week, the sky is a bit overcast this morning. But that burns off after I get going on I-95—southbound—on a sunny, 200-mile ride to West Palm Beach, where I'll be visiting family for several days. After that, I'll cross the state to visit more family and friends around Tampa Bay, as well as in Gainesville in north Florida, before riding north to Vir-

ginia in a couple weeks. I am exceedingly hopeful that by then spring will have overtaken winter.

This is a perfect day for riding, and I bask in the clear skies and mild midday breezes while continually plotting to stay in my yellow zone of relative safety. That proves not too difficult on this fairly calm, wide-open stretch of road. I have described the sensational experience and visceral enjoyment of operating a motorcycle. Our senses are heightened while riding and our experience is made more complete. Traveling by motorcycle rewards us as it prolongs the journey and facilitates greater interaction with our environment and with others. Today, once again, I experience that motorcycling is more than simply a matter of transporting oneself from point A to point B.

In the few years since we rode together at Bike Week, Jinks has "added to the stable" a second Harley, a 1993 Low Rider. Most recently, he added a BMW K1200 touring bike. "It was intended as a dealer-serviced highway beater but has become a favored ride," he said. Wolfpup also has added to his lineup. He now has a Honda 919 and a Honda Gold Wing. As for his Harley, "Stokely," it has seen considerable modification, including a 113-cubic-inch motor, front end, wheels, brakes, paint, and a hand shift and hydraulic clutch that he designed himself. "No matter what state of completion it's in, any Harley is a starter kit," Wolfpup said. "I just can't seem to keep from messing with them."

With Wolfpup living in Washington State for a few years, both he and Jinks made runs across the country to visit each other. Most recently, Wolfpup rode his Gold Wing to Bike Week 2003, arriving just in time to meet with friends from the Virtual Bar and Grill. That was the reason for the trip, Wolfpup said. "I've grown pretty tired of both the increased numbers and what seems to me to be deteriorating behavior at the big events." Jinks has bought a small home in Ormond Beach, and during Bike Week he makes it a base camp for the extended biking family of the VB&G. The home insulates them from the center of the Bike Week storm, but they still can feed off the energy at its outer edges.

When I asked about their non-Harley acquisitions, Jinks and Wolfpup gave practical explanations that conveyed little concern that they might be straying from some kind of allegiance to Harley-Davidson or to some brotherhood of biking. For example, both having ridden other brands before, they searched widely for more spacious touring bikes. "I've never been brand exclusive, so it wasn't a big change for me," Jinks said.

But didn't riding a non-Harley at Bike Week—where you see stickers reading "I'd rather push a Harley than ride a Honda" and where Japanese motorcycles are ceremonially dropped, bashed, and burned—subject them to some degree of exclusion? "I'm too old to feel differently about my experience at any motorcycle event because of the view of other riders," Jinks said. Wolfpup said that with age he, too, has grown comfortable in being who he is regardless of appearances. He said he did notice being treated differently while riding his Gold Wing through Arizona on the way to Daytona, when a couple of Harley riders passed him without any acknowledgment. "If I'd been on Stokely it would have been different," he said. "They'd have waved, nodded, [or] whatever their personal cool level allowed."

Throughout our conversations, Jinks and Wolfpup consistently downplayed the brand of motorcycle one

rides, the way it is ridden, the extent to which one trailers, and other variations on the theme of real bikers versus poseurs. These topics often attract lively debate because they are visible measures of how authentic a biker one is. Useful as these indicators may be when deeper investigations are not possible, they remain imprecise measures that inevitably lead to a certain degree of overgeneralization. Furthermore, Jinks and Wolfpup clearly see the community of motorcycle riders as having primacy over the community of Harley-Davidson riders. For them, whatever is distinct in Harleydom is not as important as what is common to all motorcyclists.

With their emphasis on the substance of authenticity, bikers like Jinks and Wolfpup seek to distinguish between those who are committed to motorcycling and those who are either pretending to be bikers, are merely playing biker for the short term, or are otherwise insufficiently committed to biking. Wolfpup

related authenticity to such "cardinal virtues" as integrity, trustworthiness, honesty, and reliability. Moreover, he said, authenticity has a particular significance among motorcyclists. "Can Jinks trust me to ride eight inches to his right in a single lane at 80 miles per hour all the way across the country? Can he trust me to do that time after time, mile after mile, trip after trip, and never ever do the stupid thing that's going to kill him?" he asked. "Only by seeing my commitment to riding . . . can he know that."

Authenticity has no doubt always been a variable quality at Bike Week. However, the considerable social changes at Bike Week since the 1980s have increased the significance of authenticity as a distinguishing characteristic among bikers. This value on authenticity is not simply a way to discriminate between the traditionalists and the newcomers. Rather, at face value, it is a means of ultimately distinguishing between the fake and the authentic.

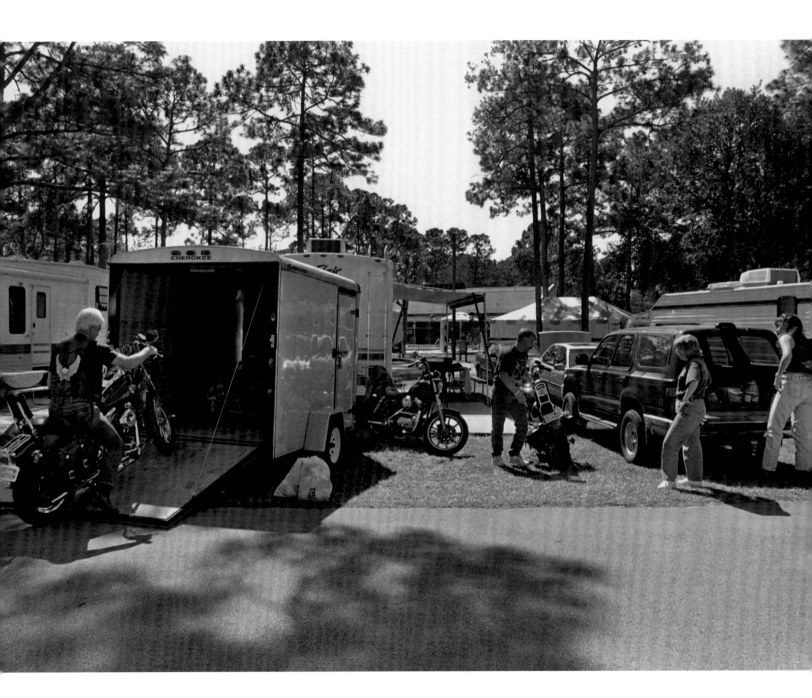

Jinks (left) rolls out his bike

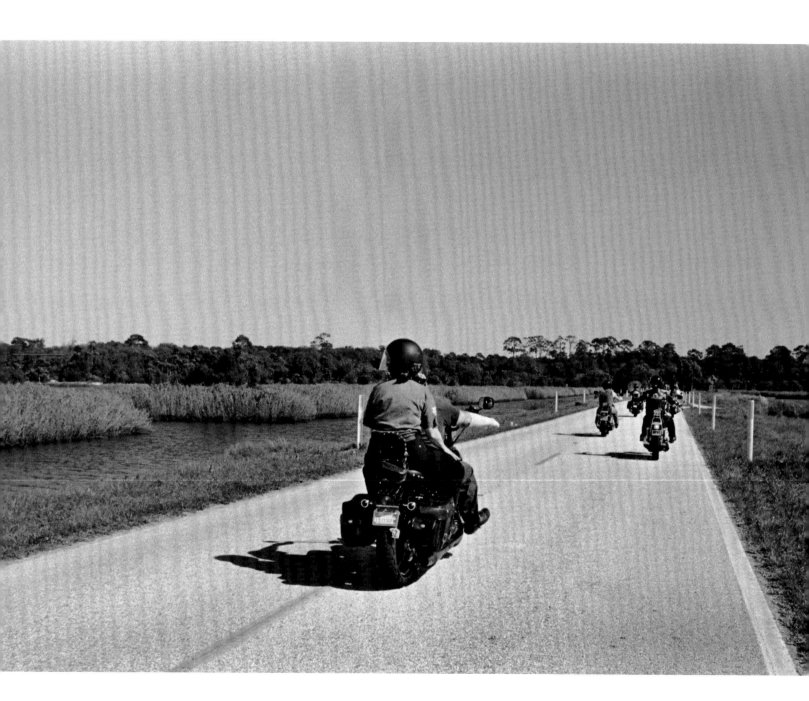

Wolfpup and Ms Mouse take 'Stokely' along the Tomoka River

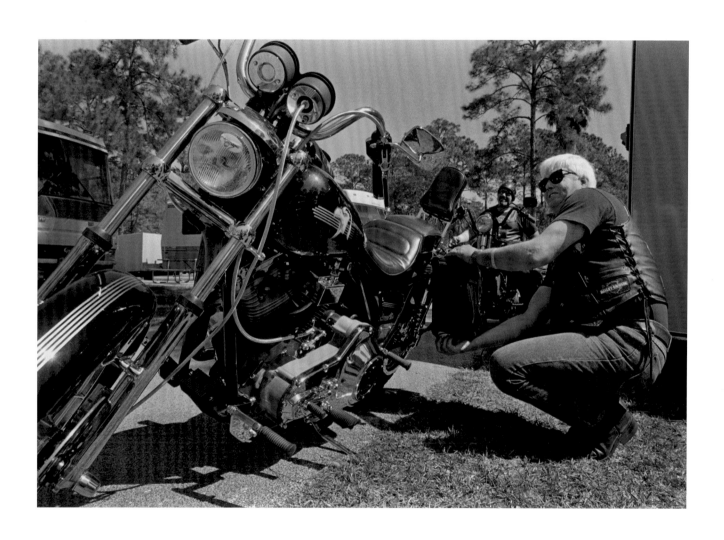

Jinks adjusts his saddlebag as Wolfpup awaits

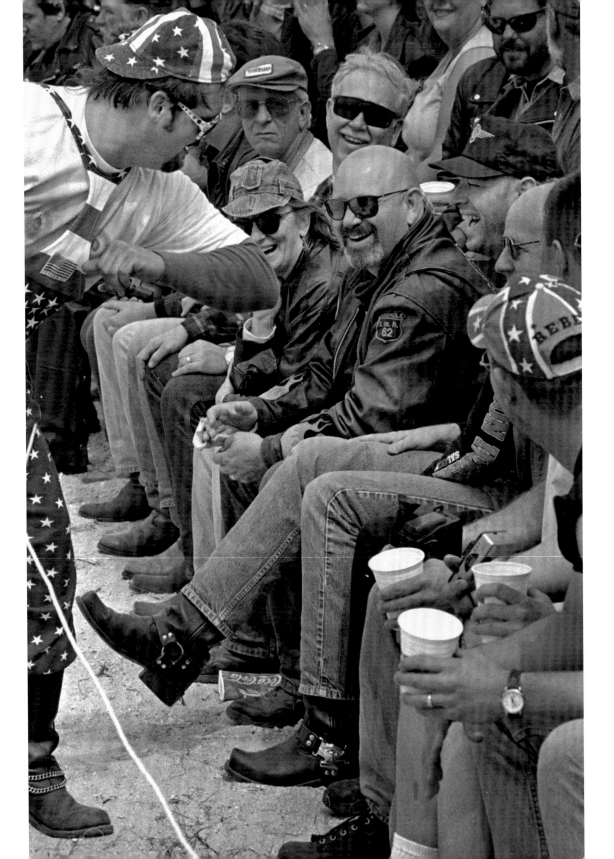

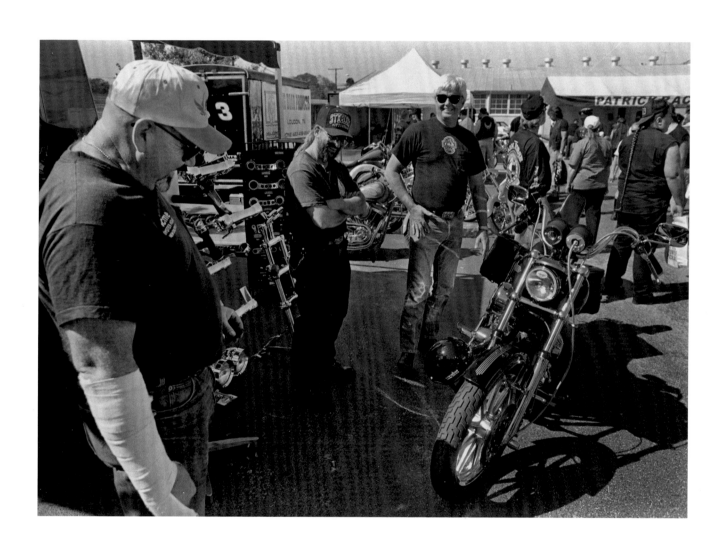

Wolfpup (left) looks on as Jinks acquires a new front axle nut on Beach Street

Left: Wolfpup and Ms Mouse await the slaw wrestling at the Cabbage Patch

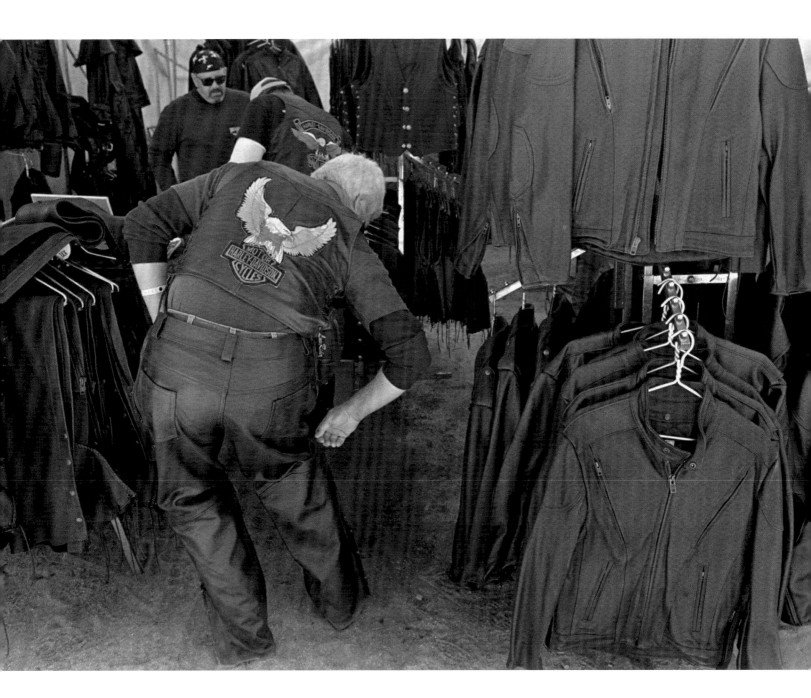

Jinks tries out a pair of pants at the swap meet

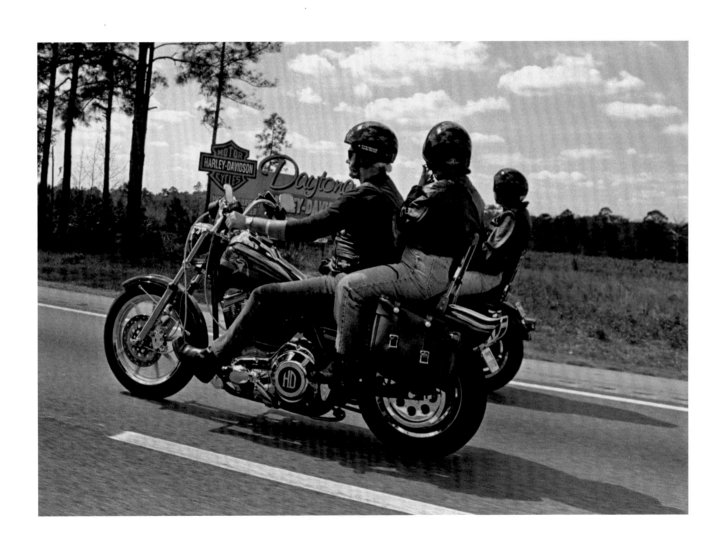

Jinks and Linda southbound on I-95 Friday

Wolfpup (right) chats with a vendor at the Speedway

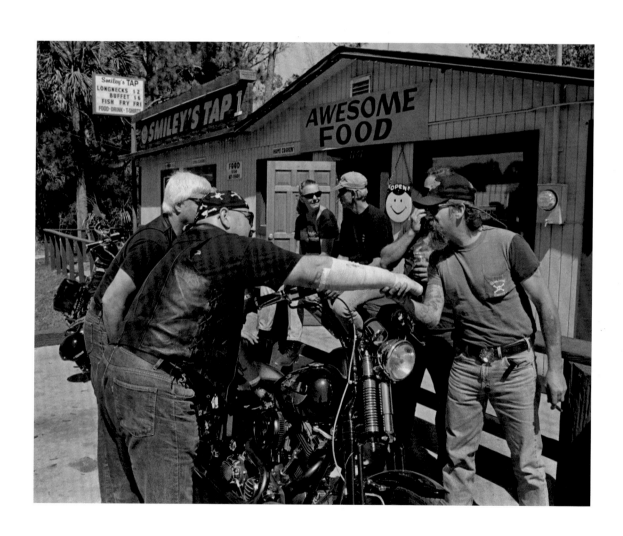

Wolfpup and Jinks (left) make an acquaintance at Smiley's Tap | 137

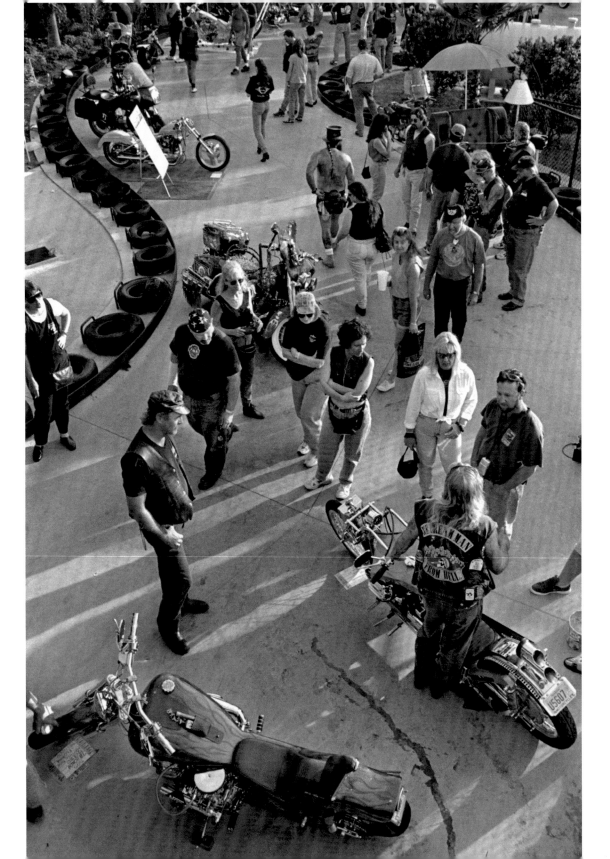

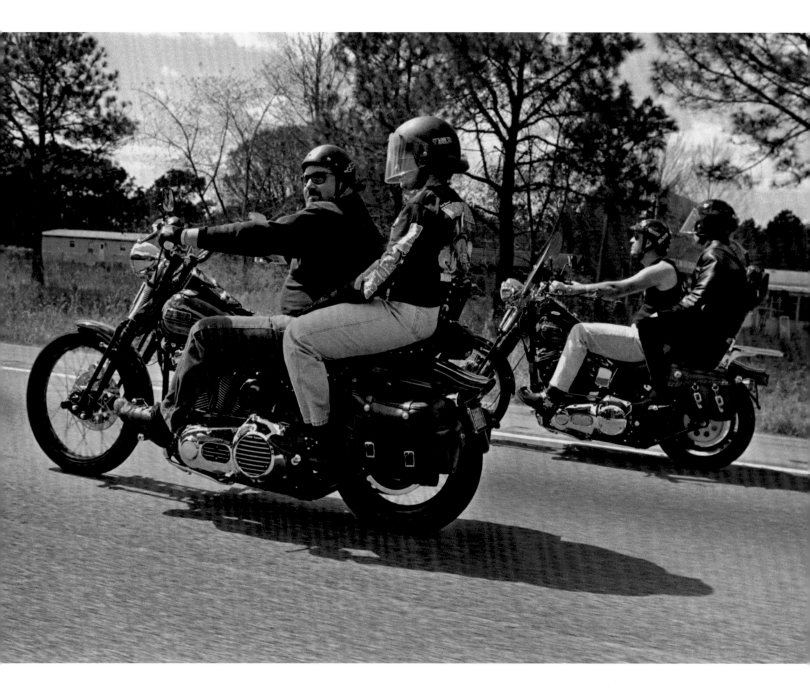

Wolfpup and Ms Mouse southbound on I-95 Friday | **139**

Left: Wolfpup and Ms Mouse (left center) at the Rat's Hole Custom Chopper Show

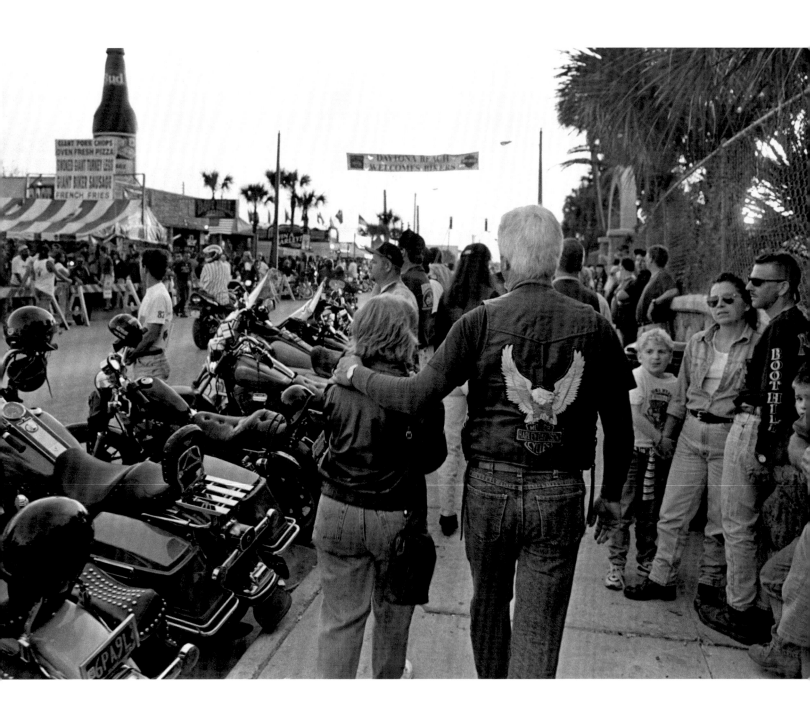

Jinks and Linda make their way up Main Street toward the Boot Hill Saloon

Jinks (right) and Wolfpup at Smiley's Tap

Jinks and Linda at the Boot Hill Saturday evening

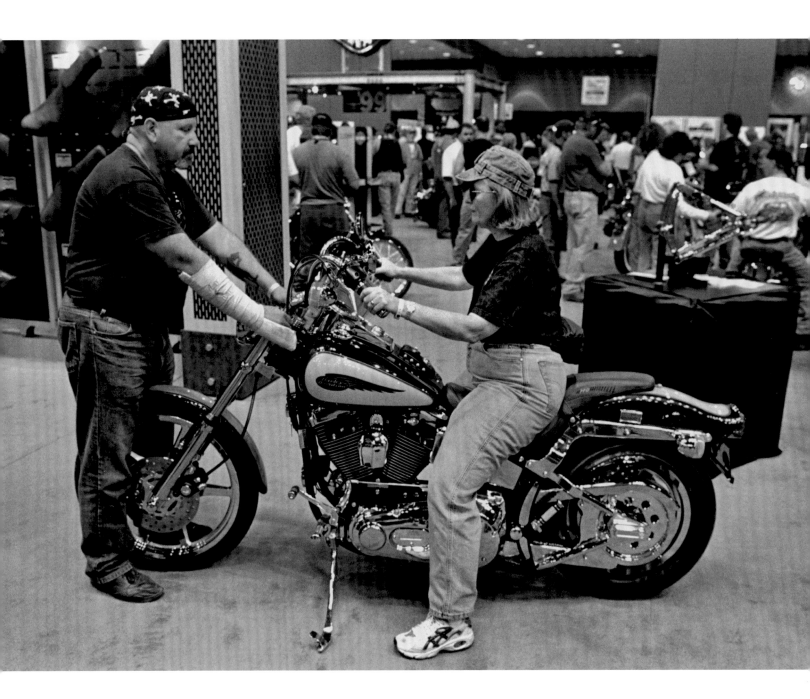

Wolfpup looks on as Ms Mouse tries out a Harley at the Ocean Center     **143**

Preparing for departure Sunday morning

# Notes

## INTRODUCTION

1. *Newsweek*, September, 7, 1998, p. 80.

## ON THE ROAD TO BIKE WEEK

1. John W. Schouten and James H. McAlexander, "Subcultures of Consumption: An Ethnography of the New Bikers," *Journal of Consumer Research* 22 (1995): 43–61.

## BIKERS AND BOUTIQUES

1. *Fortune*, September 25, 1989, pp. 155–64.
2. *Money*, April 1992, p. 72.
3. *Time*, December 13, 1982, p. 61.
4. *Time*, December 13, 1982, p. 61, April 11, 1983, p. 74; *Forbes*, April 20, 1987, p. 8.
5. *Forbes*, December 2, 1985, pp. 14–16; *Fortune*, 25, 1989, pp. 155–64.
6. *Fortune*, September 25, 1989, pp. 155–64
7. *Newsweek*, March 30, 1987, p. 50; *Business Week*, August 17, 1987, p. 78.
8. *Fortune*, September 25, 1989, pp. 155–64.
9. *Business Week*, May 24, 1993, pp. 58–60; *Money*, April 1992, p. 72.
10. *Business Week*, October 20, 1997, pp. 159–60.
11. *Forbes*, March 10, 1997, pp. 114–19.
12. *Business Week*, April 8, 1996, pp. 90–94.
13. *Esquire*, July 1989, pp. 22–26; *Kiplinger's Personal Finance Magazine*, May 1998, p. 72; *Forbes*, March 10, 1997, pp. 114–19; *Fortune*, September 25, 1989, pp. 155–64.
14. *Forbes*, May 15, 2000, pp. 68–70; 2003 Harley-Davidson, Inc. Annual Report, www.harley-davidson.com.
15. Danny Lyon, *The Bikeriders*, 2nd ed. (1967; rptr., Santa Fe, N.M.: Twin Palms, 1997), p. vii.
16. "Cyclist's Holiday: He and Friends Terrorize a Town," *Life*, July 21, 1947, p. 31. Photography by Barney Petersen.
17. "*Life* Goes Motorcycling," *Life*, August 11, 1947, pp. 7, 112–17. Photography by Robert W. Kelley and Sam Shere.
18. Frank Rooney, "Cyclists' Raid," *Harper's*, January 1951, pp. 34–44. Drawings by David Berger.
19. Art Simon, "Freedom or Death: Notes on the Motorcycle in Film and Video," in *The Art of the Motorcycle*, ed. Matthew Drutt, pp. 68–81 (New York: Guggenheim Museum, 1998).
20. Hunter S. Thompson, *Hell's Angels: A Strange and Terrible Saga* (New York: Ballantine Books, 1967), pp. 58–59.
21. For example, see Lyon, *The Bikeriders*, pp. 19–20.
22. Ted Polhemus, "The Art of the Motorcycle: Outlaws, Animals, and Sex Machines," in Drutt, *Art of the Motorcycle*, pp. 48–59; Thompson, *Hell's Angels*, pp. 60–62, 66.
23. Although many media reports have inserted an apostrophe in its name, the Hells Angels Motorcycle Club does not use the apostrophe.
24. Polhemus, "Art of the Motorcycle," p. 52.
25. Ibid., p. 50.
26. Yves Lavigne, *Hell's Angels: Three Can Keep a Secret If Two Are Dead* (Secaucus, N.J.: Lyle Stuart, 1996); Polhemus, "Art of the Motorcycle," p. 51; Thompson, *Hell's Angels*, p. 127. See also William Murray, "Hell's Angels: A Searching Report on What's Behind the Strange Cult of Motorcycle Gangs," *Saturday Evening Post*, November 20, 1965, pp. 32–39. Photography by Wayne Miller, Bob Grant, and Don Mohr.
27. See "The Wilder Ones," *Time*, March 26, 1965, p. 23B; "The Wild Ones," *Newsweek*, March 29, 1965, p. 25; and Murray, "Hell's Angels," pp. 32–39.
28. Thompson, *Hell's Angels*, pp. 35–39.
29. See Thompson, *Hell's Angels*; and Lavigne, *Hell's Angels*.
30. Robert M. Pirsig, *Zen and the Art of Motorcycle Maintenance* (New York: William Morrow, 1974).
31. *Forbes*, March 10, 1997, pp. 114–19.
32. *Business Week*, April 8, 1996, pp. 90–94; *Esquire*, October 1994, pp. 72–75.
33. *Business Week*, April 8, 1996, pp. 90–94. See also *Forbes*, March 10, 1997, pp. 114–19; *Smithsonian*, November 1993, pp. 88–99.

## BIKE WEEK AT DAYTONA BEACH

1. *Daytona Beach Sunday News-Journal*, February 28, 1999.
2. *Daytona Beach Sunday News-Journal*, March 12, 2000.
3. *Daytona Beach News-Journal*, March 4, 2000.

4. *Daytona Beach News-Journal*, March 8, 2000.

5. *Daytona Beach Evening News*, June 7, 1985.

6. *Daytona Beach Evening News*, December 31, 1985, February 14, 20, May 20, April 25, June 25, 26, 1986; *Daytona Beach News-Journal*, Oct. 29, 1986.

7. *Daytona Beach Evening News*, February 21, July 30, 1986; *Daytona Beach News-Journal*, February 5, 1987.

8. *Daytona Beach Evening News*, April 25, 1986.

9. *Daytona Beach News-Journal*, March 2, 1987.

10. *Daytona Beach News-Journal*, March 20, 1996.

11. *Daytona Beach News-Journal*, August 13, 1987.

12. *Daytona Beach News-Journal*, August 14, 1987.

13. *Daytona Beach Sunday News-Journal*, March 12, 2000; *Daytona Beach News-Journal*, March 4, 2000.

14. *Daytona Beach Sunday News-Journal*, March 12, 2000.

15. *St. Petersburg Times*, March 2, 2002.

16. *Daytona Beach News-Journal*, February 28, 2003.

17. *Daytona Beach News-Journal*, February 28, March 2, 2003.

## THE PURSUIT OF AUTHENTICITY

1. Schouten and McAlexander, "Subcultures of Consumption."

All subsequent quotations from these authors are from this source.

2. *Daytona Beach News-Journal*, March 5, 2002.

3. *Forbes*, March 30, 1981, p. 128.

4. *Smithsonian*, November 1993, p. 88.

5. *Business Week*, October 20, 1997, p. 159; *American Demographics*, June 1999, p. 24.

6. *Esquire*, October 1994, p. 72.

7. *American Demographics*, June 1999, p. 24; *Kiplinger's Personal Finance Magazine*, May 1998, p. 72.

8. David Brooks, *Bobos in Paradise: The New Upper Class and How They Got There* (New York: Simon and Schuster, 2000).

9. *Newsweek*, April 3, 2000, p. 63.

10. Ibid.

11. Juliet B. Schor, *The Overspent American: Why We Want What We Don't Need* (New York: HarperCollins, 1998).

12. Brock W. Yates, *Outlaw Machine: Harley-Davidson and the Search for the American Soul* (Boston: Little, Brown, 1999).

13. Ibid.

14. George Ritzer, *The McDonaldization of Society*, rev. ed. (Thousand Oaks, Calif.: Pine Forge Press, 1996).

# Index